OTHER BOOKS IN THE SERIES

Andy Grundberg

Crisis of the Real: Writings on Photography, 1974-1989

Estelle Jussim

The Eternal Moment: Essays on the Photographic Image

Wright Morris

Time Pieces: Photography, Writing, and Memory

Nancy Newhall

From Adams to Stieglitz: Pioneers of Modern Photography

In Our Own Image

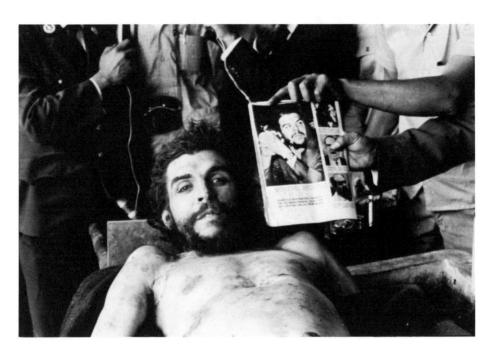

Frontispiece: "The proof of the proof." The Bolivian army shows the body of Che Guevara to the press, Vallegrande, Bolivia, October 11, 1967. Photograph by Freddy Alborta.

FRED RITCHIN

In Our Own Image

The Coming Revolution in Photography

HOW COMPUTER TECHNOLOGY IS CHANGING OUR VIEW OF THE WORLD Copyright © 1990 by Aperture Foundation, Inc. Text copyright © 1990 by Fred Ritchin. Photograph copyrights listed on page 150. All rights reserved under International and Pan-American Copyright Conventions. Composition by David E. Seham Assoc., Inc., Metuchen, New Jersey. Printed by Arcata Graphics, West Hanover, Massachusetts.

The paper used in this publication meets the minimum requirements of American National Standards for Informational Sciences—Permanence of Paper for Printed Library Materials, ANSI Z39.48-1984. ⊗

Library of Congress Catalog number 90-80727 Hardcover ISBN 0-89381-398-2; Paperback ISBN 0-89381-399-0

The staff at Aperture for *In Our Own Image* is Michael E. Hoffman, Executive Director; Steve Dietz, Vice President, Editorial—Books; Emanuel Voyiaziakis, Assistant Editor; Shelby Burt, Editorial Work-Scholar; Stevan Baron, Vice President, Production; Linda Tarrack, Production Associate.

Series editor: Steve Dietz. Series design: Wendy Byrne.

Aperture Foundation, Inc., publishes a periodical, books, and portfolios of fine photography to communicate with serious photographers and creative people everywhere. A complete catalog is available upon request. Address: 20 East 23 Street, New York, NY 10010.

Contents

Illustrations viii			
Preface xi			
Acknowledgments xiii			
Into the Information Age 1			
The Pixellated Press 8 Modifying New York's Skyline 27			
Computers Don't Kill People 31			
Bringing Back Marilyn and Other Complications 64			
Reading Photographs 81			
Authoring the Image 110			
Photographing the Invisible 131			
In Our Own Image 142			
Notes 147			
Picture Credits 150			
Selected Bibliography 152			
Index 153			

Illustrations

Froi	Frontispiece. "The Proof of the Proof," Freddy Alborta			
1.	"The Big Lie," New York Daily News 6			
2.	"Rain Man" composite, Newsweek 10			
3.	Dustin Hoffman and Tom Cruise's stand-in, Douglas			
	Kirkland 12			
4.	Retroactively repositioning the author, National			
	Geographic 15			
5.	Simulated National Geographic cover, Guenther			
	Cartwright and Blair Richards 16			
6.	Electronic gun control of Don Johnson, Rolling			
	Stone 18			
	"Elastic" covers of A Day in the Life of America 19			
8.	Electronic simulation of the racial makeup of the			
	world's population, 2025, <i>Life</i> 24			
	Manipulating New York's skyline, Fred Ritchin 28			
	"This is War!" Robert Capa 34			
	El Salvador, Susan Meiselas 39			
	The photographic cliché at <i>Time</i> and <i>Newsweek</i> 40			
	How Goes the Press? UPI 43			
14.	"The Bishop at Ground Zero," Douglas			
	Kirkland 47			
	"'I Am a Coke Addict," Life, 1986 49			
16.	"'We Are Animals in a World No One Knows,"			
	Life, 1965 55			
17.	"Xapshots," still video camera ad, <i>Life</i> 66			

18.	Photography as visual data, MIT's	''range
	camera'' 70	
19.	Still from first computer-generated,	Oscar-

- Still from first computer-generated, Oscar-winning film,
 Tin Toy 75
- 20. "Dozo," the "sexy cyborg," Jeff Kleiser and Diana Walczak 77
- 21. "This picture is a fake!" Science 84 79
- 22. Separating the criminals from the writers, *Life* 82
- 23. Edward Kennedy, womanizer? loner? monsignor's companion? *The Washingtonian* 86
- 24. "The Savage Pit," Geo 89
- 25. Falling Soldier, 1936, Robert Capa 98
- 26. *Quinceañera*, "sweet fifteen," Maria Eugenia Haya (Marucha) 102
- 27. Baseball American style, *New York Times Magazine;* the symbolic Pope, *Paris Match* 106, 107
- 28. Vu's early lyric 108
- 29. "A Vision of Iran," Gilles Peress 115
- 30. American dead in Vietnam, week of June 27, 1969, *Life* 117
- 31. Vietnam Inc., Philip Jones Griffiths 119
- 32. Beirut, Sophie Ristelhueber 122
- 33. Campaigning in France, Raymond Depardon 124
- 34. *The Monroe Doctrine, Theme and Variations*, Esther Parada 126
- 35. Visual representation of a monkey thinking, A.P. Georgopoulos 133
- 36. Warhead I, Nancy Burson with Richard Carling and David Kramlich 137
- 37. Untitled, Nancy Burson 138

Preface

This book is intended to provoke discussion, both among those who work professionally with photography and those whose primary experience of photography is as a reader, and between these groups. It was written in appreciation of the important historical juncture at which we stand, just before the widespread adoption of electronic technology, out of a sense that we must try to take some responsibility for the future of the immensely popular and still believable medium of photography. This book was also made with the awareness that there are many new and fruitful avenues of exploration that will inevitably emerge from the marriage of computer and photography, whose synergistic potential rivals photography's original promise of 150 years ago.

In Our Own Image was written by someone whose professional life has largely taken place in the offices of the mass media, assigning, researching, and selecting photographs on a daily basis. If there is an urgency in the book's arguments, it is derived from a perception that although the technology of mass communications is rapidly evolving, the concomitant issues concerning the content and fabric of such communication are barely being addressed. Neither those responsible for the photography we as a society see nor those who rely upon such imagery seem particularly aware of the eventual impact of the remarkable changes underway. But for me it has become clear, particularly through lecturing and teaching in this country and abroad, that there are many who, once informed, would like to be in on the discussion.

Acknowledgments

There are many to whom I am grateful, too numerous to mention, who made the solitary journey of the writer more social, stimulating, and even at times fun. The many photographers I have met here and in other countries have in large part inspired the writing of this book. With photographers Pedro Meyer and Gilles Peress I have discussed specific issues of *In Our Own Image* over many years. I am especially grateful as well to their colleagues Diego Goldberg, Susan Meiselas, Sylvia Plachy, Eugene Richards, and Sebastião Salgado for their friendship and help in opening doors both conceptual and emotional. Tom Drysdale at New York University generously provided a base, and Phil Block, Nancy Burson, Mark Bussell, Tim Druckrey, Karen Kelly, David Kramlich, Nancy Meiselas, Robert Pledge, Hillary Raskin, and Nan Richardson offered timely and much-appreciated aid. John Goodell was an early guide into the world of computer technology, and Ron MacNeil unknowingly helped with some offhand but extremely good advice.

Among the many editors I have worked with, Mark Holborn, Jim Hughes, Margarett Loke, Jim Mairs and Carol Squiers in particular commissioned essays and articles that helped to strengthen the thinking that went into this book. Steve Dietz of Aperture believed in the importance of the issues expressed, and played an active and consistent role in bringing *In Our Own Image* to fruition. I am very grateful to him.

My brother Steve has been my longtime and indispensable editor and friend, and my parents Estelle and Hyman have provided an enduring foundation. There is also one person who has had to put up with the exigencies and pure craziness of this and other projects while continually giving advice, and it is to her, and to our son Ariel, that this book is dedicated. To Carole.

Into the Information Age

The plates of the present work will be executed with the greatest care, entirely by optical and chemical processes. It is not intended to have them altered in any way, and the scenes represented will contain nothing but the genuine touches of Nature's pencil.' 1844 advertisement for William Henry Fox Talbot's The Pencil of Nature, the first published photographic book

ONE HUNDRED FIFTY YEARS AFTER its invention, photography is nearly omnipresent, informing virtually every arena of human existence, comparable to the printing press in its impact on the ways in which we view the world. Moreover, due to its mechanical, apparently objective nature and to its near replication of human sight, we often confuse photography with truth: "The camera does not lie."

But we are mistaken. Photography's relationship with reality is as tenuous as that of any other medium. We are used to regarding the photograph, particularly in the journalistic or documentary context, as a powerful indicator that in its easy comprehension is innocent both of deception and the intent to deceive. Yet photography, despite its apparent simplicity, constitutes a rich and variegated language, capable, like other languages, of subtlety, ambiguity, revelation, and distortion.

The common error is to confuse, in the stasis and apparent certitude of visual realism, the representation with the thing itself: the frozen instant, the slice from space with the more fluid, interconnected life to which it merely refers. There is something seductive about a medium that is alleged to be able to capture "nothing but the genuine touches of Nature's pencil." But the photograph is not on such proximate terms with Nature; neither does Nature draw itself but is, even in the most straightforward photograph, interpreted. And despite the photograph's promising profusion of visual details, it remains bound to represent that which exists in discrete, decontextualized moments. The photographer is assured only of snaring momentary appearances; a situation's essence, its deeper meanings, may remain elusive.

This is not to say that the photograph lacks depth—only that it may reach it as much through the ambiguity of metaphor as through the sharpness of the lens, the display of visual fact. One can collect butterflies and pin them to a board, making them easy to see and verify, but what then has become of their essential flutter?

Without this reliance on palpable fact, however, photographic currency, like that of painting, becomes the imagination. It loses its perceived character as faithful witness and helpful companion, modestly transcribing appearances for the viewer to reexperience as if he or she were there. The painter, it is thought, is a talented author who largely re-creates the world for the viewer; conversely, the photographer, for all his or her skills, is fundamentally perceived as someone who can be depended upon to press a button and record how things, if one had only been there, would have looked.

What would happen then if the photograph appeared to be a straight-forward recording of physical reality, but could no longer be relied upon to depict actual people and events? What if the woman shown in photographic detail standing on a mountaintop never stood on that particular mountaintop; or if neither she nor the mountain ever existed? In a sense, photographic currency would be transformed to parallel that of words or painting: "The apple is on the table," whether spoken or drawn, may be only a concept, or it may represent an actual apple on a table. One can only act upon the information in the sentence if one understands the context in which it is given. Similarly, a photograph of an apple on a table would refer either to an idea or to an actuality, depending upon its context.

But that is not the way photographs are read now. Scenes photographed in a straightforward way are presumed to have contained the people and objects depicted. Unless obviously montaged or otherwise manipulated, the photographic attraction resides in a visceral sense that the image mirrors palpable realities. Should photography's relationship to physical existence become suddenly tenuous, its vocabulary would be transformed and its system of representation would have to be reconsidered. Our view of it as relatively unmediating and trustworthy would then become untenable. Rather than confirming human perception in the quasi-language of sight, the photograph becomes increasingly ephem-

eral. It is a fundamental change that, inexorably and without much attention, is already underway.

Recently, on a New York City subway, looking at the advertising photographs placed above the heads of the people sitting across from me, I tried to imagine how it would feel if, despite the evidence of the photographs, everything depicted in them had never been. It was difficult to do because the images seemed so lifelike. I could hardly imagine that the small, slender, smiling man advertising paper towels, depicted in a dark suit with close-cropped hair and arms outstretched, had never lived. If so, the photograph referred to nobody. Suddenly, it was disturbing, as if despite the exactitude of realistic details nobody was in the suit, that the suit itself had never existed. The point was not whether the man being represented was a model, but was he, looking so much like the people sitting on the seats below him, somewhere a man?

In another photograph, a man said to be blind was shown giving a speech at a lectern. The photograph, awkward and harshly lit, seemed to have the timeliness of a news photograph. What kind of imagination would one have needed to concoct such an ugly and unadorned image if none of the people in it had ever existed? Or, more simply, what if the man at the lectern had never spoken to the audience shown in the photograph, and they had never been in the same place at the same time?

As I stared more, at images of people in business suits, on picnics, in a taxi, I became frightened. I looked at the people sitting across from me in the subway car underneath the advertisements for reassurance, but they too began to seem unreal, as if they also were figments of someone's imagination. It became difficult to choose who or what was "real," and why people could exist but people looking just like them in photographs never did. I became very anxious, nervous, not wanting to depend upon my sight, questioning it. It was as if I were in a waking dream with no escape, feeling dislocated, unable to turn elsewhere, even to close my eyes, because I knew when I opened them there would be nowhere to look and be reassured.

A century and a half after photography's debut there is a revolution in image-making underway that is beginning to remove the accepted cer-

tainties of the photograph and to make the world newly malleable. The capabilities of the computer—the juggler of data at the heart of the current information age—are now being turned toward photography. The computer is increasingly being used to manipulate the elements of photographs and quickly and seamlessly rearrange them. People or things can be added or deleted, colors modified, and images extended. The computer's retouching capabilities are more efficient, subtle, reliable, and undetectable than ever before.

The initial wave of the revolution in image manipulation has first come to the mass media, due both to the originally high price of the technology and the desire by many editors to exercise greater control over the photographs they are publishing. It is in the public forum of photojournalism that the ethical and philosophical dilemmas of undetectable (and often secret) computer modification of photographs are acquiring urgency. These modifications, as they eventually become known and more widely understood, threaten not only to further diminish the public's trust in journalism but to resonate outward. They promise to significantly revise society's general use of and relationship to the photograph and, in combination with other forces, people's perceptions of the world itself. Further technological changes beyond this first wave are also appearing. The recently introduced still video camera records images on reusable magnetic disks without requiring film or paper, bypassing the chemically produced, archival, and hence verifiable, photographic negative. This development further complicates the possibilities of detecting photographic manipulations.

More fundamentally, it is now possible for the first time to bypass both the 150-year-old optical and chemical processes that physically defined photography. Without using a camera, lens, or film, images are being mathematically synthesized on computers in an attempt to simulate the perceived authenticity of photographic realism. (This process, in its most basic form, is like plotting a circle or some other form on a graph, making the mathematics visible.) The attempt is even being made to simulate a human being that can appear in a film moving and talking.

Not only journalism, but snapshots and documentary photography of every sort will be affected. Cultural history, political events, personal memories—all will be newly suspect while the photograph's long reign as society's high-tech but humble scribe becomes increasingly vulnerable. Art photography as well will no longer draw much of its strength and context from a perception that it is inherently a comment on visible, verifiable realities, but will come more easily to be seen, like painting, as synthetic, the outcome of an act from the artist's imagination.

With this technology, the photograph can be newly orchestrated, made to fulfill any desire. The viewer cannot tell what is being depicted and what projected. The world, rather than speaking to us in the dialectic of the conventional photograph, imposing itself on the image as it is simultaneously being interpreted, becomes more controllable, and we become more capable of projecting and confirming ourselves and our world in our own, or any other, image.

In this age of heightened media influence in international relations, it may paradoxically become more difficult to show a photograph of a victim of torture and expect anyone to be not only moved but convinced by it. Although the recent events in China following the massacre in Tiananmen Square show the apprehension an authoritarian government may have about photography's witnessing function, in the future such governments may have less reason to fear. They will be able to manufacture their own suitably manipulated photographic versions of events. Eventually, if the fact-based photographic currency is sufficiently devalued, they may not even feel the need to limit access to photographers, as was done recently in China, South Africa, Grenada, the Falklands, and elsewhere. They may see it as perfectly fine to have photographers roaming about—in the context of electronic photography they could deny the veracity of the newly malleable image. In this way, the electronic image may present authoritarian governments with yet another strategy for defending themselves against external criticism or internal dissent. But even in democratic societies, photography's role in providing rallying symbols for dissidents—such as the famed image of the point-blank execution of a member of the Viet Cong-may be more easily discredited as well. Similarly, photographs used in missile verification treaties, as evidence in court, or of marriage ceremonies, will be newly suspect.

Challenges to the medium's veracity are not new with the computer.

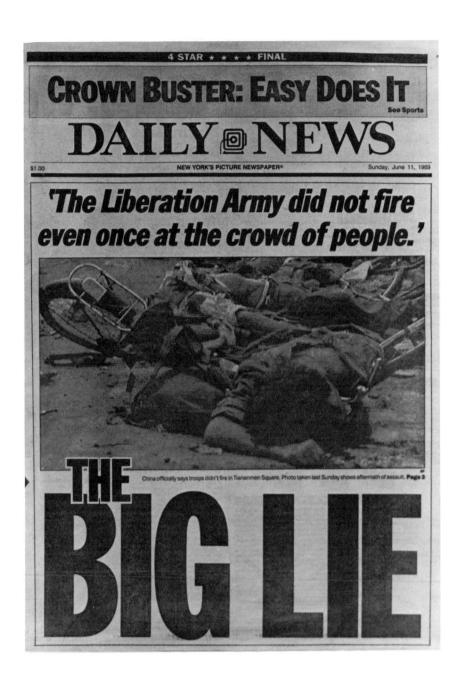

^{1.} In the future, governments may be less afraid of the documentary evidence of photography if it becomes thought of as a medium that is largely fabricated. "The Big Lie," *New York Daily News*, June 11, 1989.

Photography's linguistic potential has not been adequately valued or assessed, while its facile connection to reality has been overstressed. Photojournalism in particular, the highly visible and critical arena into which electronic photography has entered with unsettling effect, has been thought of simplistically and remains vulnerable to misuse. Today, photojournalism's illustration of preconceived notions and formulaic coverage have largely replaced the exploration and discoveries first promised, and at times achieved. Sensationalism and slickness weaken photography's power to arouse. It is less likely, for example, that photographs could again be perceived as powerfully as they were during the Vietnam War, when they helped instigate and fuel a furious public debate. Their import, even without the computers, has already been quietly diminished, even as many of those who produce them are granted center stage.

Despite its various distortions, the popular authority of photography as a transcription from reality has largely persevered. At a basic level, as a chronicle of the "genuine touches of Nature's pencil," the photograph still holds a descriptive power that remains convincing and lends strength to its various levels of meaning. The computer, allowing a new and bold conceptual approach to imaging, offering the easy exchange of visual and other elements, as well as ways of depicting the invisible, is the portentous addition to the mix. It is this juncture, with its enormous implications for world communications and knowledge, that is the subject of this book.

The Pixellated Press

A MOVIE ABOUT AN AUTISTIC, emotionally disconnected savant and his relationship with his brother is not likely to be a popular success, let alone made in Hollywood. Yet, after five years, four directors, six screenwriters, and at least eight producers, *Rain Man* emerged not only to immediate critical acclaim but as a runaway box office smash as well: audiences paid \$42.4 million the eighteen days following its release.

Interested? So was I. Reading *Newsweek* magazine, which gave the movie the second headline on its cover—"'Rain Man' Strikes It Rich: Star Turns for Cruise and Hoffman" (a story on chemical warfare was featured)—I found that much of the credit for the movie's success was given to the presence of the two actors, Dustin Hoffman and Tom Cruise. Hoffman is said to have "felt a kinship [for Cruise] from the beginning, recognizing a fellow workaholic when he met one."

Eager to better understand this relationship, I looked closely at a photograph of the two actors standing next to each other printed large on the article's opening pages. The younger Cruise tilts toward the center of the image, looking straight at the camera with a shy, sweet grin, seeming to hang back a little behind the more self-involved Hoffman, who, standing erect, is laughing and looking off somewhere else. They are dressed similarly in gray tweed, but Cruise is wearing a sports jacket and knit shirt conservatively buttoned all the way to the top; Hoffman appears a bit rougher in a tweed overcoat with the collar turned up in back and his dress shirt unbuttoned (figure 2).

Their relationship as depicted in this image not only confirms Cruise in his role as supporting actor, but also corroborates the description in the accompanying text. The article mentions how Cruise used to sit out-

side Hoffman's California home with other young actors, "staring into his windows and daring each other to go knock," and was "gung-ho to act with his idol Hoffman." Hoffman, in turn, is described as "a ferocious perfectionist" who when he "gets a role, he's like a dog with a bone; no one's gonna take it away from him."

Everything fit together rather neatly—but not for long. To my considerable surprise I discovered, in a *Wall Street Journal* article published some two weeks later, that what I had been looking at was not a photograph, but an image made by *Newsweek* using separate photographs of each man.² The actors were not together when the image was made (one turned out to have been in Hawaii and the other in New York). The caption, which simply read "Happy ending. The two 'main men' of 'Rain Man' beam with pardonable pride," does not explain that this image was not the photograph it seemed to be. There is also, although few people seem to read them, only a single picture credit.

Certainly subjects have been told to smile, photographs have been staged, and other such manipulations have occurred, but now the viewer must question the photograph at the basic physical level of fact. In this instance, I felt not only misled but extraordinarily shaken, as if while intently observing the world it had somehow still managed to significantly change without my noticing. But most unsettling for me was the point of view of the magazine's picture editor cited in the *Journal* article. In giving a rationale for such modification, Karen Mullarkey asserted that while it is taboo at *Newsweek* to retouch news photos, because it would "undermine your reputation," it is permitted for feature or fashion pictures.

I could only conclude that even in one of the most mainstream, ostensibly authoritative publications (and *Newsweek* is far from being the only one where such techniques are employed), one cannot assume that the photograph is performing its traditional descriptive function, that what one sees is what was there. Just as troubling was my realization that the Hoffman-Cruise image, which I viewed as having been published to help provide an essential understanding of the actors, was primarily illustrating and affirming the ideas of the writers and the preconceptions of editors. How can we learn anything from an image that pretends to depict an interaction of two men in the same room who

MOVIES

Who's on First?

Power, perseverance and panic in Hollywood: The saga of the struggle to make 'Rain Man' reveals the inner workings of a risky business

This is the "Rain Man" you didn't see: Charlie Babbitt is a slick, bitter, middleaged salesman (picture him as Jack Nicholson) with a girlfriend named Susan, a successful lawyer. His brother Raymond (maybe Randy Quaid), whom he's just met for the first time, is a lovable, cute, emotion-ally expressive, retarded savant with a passion for baseball. Raymond has just inherited a pile of money from their father, and Charlie wants it. As the two brothers travel across country, they are pursued by Mafia loan sharks, held up in Las Vegas and taken prisoner by white-supremacist survivalists who hold them in a barn. In the rousing climax, the retarded savant saves Charlie by putting together a motorcycle from a kit and hurtling through the flames that threaten to engulf the barn. In the heartrending denouement Charlie and Raymond watch a Dodger game together in the hills above Chavez Ravine, having chosen to live together happily ever after for the rest of their lines

he moral of the tale is that there are happy endings in Hollywood: the original "Rain Man" never got made. The one that did—starring Dustin Hoffman and Tom Cruise, directed by Barry Levinson-is in many ways the antithesis of what the movie started out to be. Instead of a lovable, retarded savant, its Raymond (Hoffman) is an autistic savant who can't emotionally connect with another person. Instead of chases and villains, it offers a character study of an angry young hustler (Cruise) who kidnaps his brother for money and is forced to deal with his own stunted emotions. Instead of a together-forever tear-jerking finale, a bittersweet but real separation. Instead of crowd-pleasing clichés, old formulas twisted into new shapes

By any conventionally cynical view of how Hollywood works-the more vulgarity the merrier-this is an unlikely metamorphosis. Perhaps more unlikely is the payoff: this slight but resonant tale of two brothers who can't communicate has become the runaway hit of the season, gro ing \$42.4 million in its first 18 days, with all

indicators suggesting it will enter the rarefied circle of movies that break the magic \$100 million mark. Oscar prognosticators see "Rain Man" in a neck-and-neck race with "Mississippi Burning" for Best Picture. Some of its success is, of course, attributable to the phenomenal star power of Tom Cruise, who can turn even a flat brew like "Cocktail" into a box-office smash. Nor can one underestimate Hoffman's time tested appeal, the Hoffman/Warren Beatty fiasco "Ishtar" notwithstanding. Many a "foolproof" star package has fallen on its overpadded fanny

By traditional Hollywood standards, "Rain Man" has only the wispiest of stories. The story of its making, however, has as many twists and turns as a year of "Santa Barbara"-it's a case study of the inner workings of the movie business. From 1984, when the idea was first dreamed up, to the time the movie was finished, it had gone through four of the biggest name directors

in Hollywood, six screenwriters, two cinematographers, one crew change, at least eight producers, a writers' strike, a threatened directors' strike, and all under the aegis of a studio-M-G-M/United Artists-that was teetering on the edge of extinction. At stake were millions of dollars, careers, reputations, executive jobs, a studio and that most precious of movietown commodities, ego. Many were the doomsayers predicting—and hoping for—disaster.
"If it didn't work," laughs Cruise, "boy, were they out there. They wanted to get us." But to understand the labyrinthine ways a movie gets made in Hollywood.

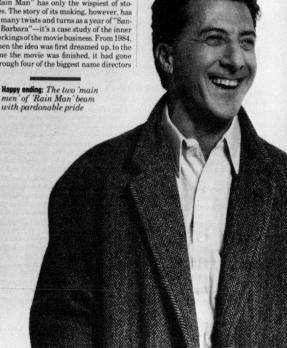

52 NEWSWEEK JANUARY 16, 1989

2. Actors Hoffman and Cruise were photographed separately in New York and Hawaii, and the two photographs were composited together. Neither the caption nor photo credit indicate this is

have to go back to the beginning GENESIS: Barry Morrow, who wrote the iginal story for the award-winning till," a Mickey Rooney TV movie about a tarded man, envisions another TV movie out a retarded savant named Raymond hen he finishes the script-with its mafii and burning barns-he pitches it to ger Birnbaum, who in the winter of 1986 the president of the Guber-Peters Co. ey option the screenplay, envisioning, in ter Guber's words, "a very small pic-re" perhaps to star brothers Randy and ennis Quaid. When United Artists bemes interested, the struggling studio es in "Rain Man" the potential for the ockbuster Christmas movie that will reve its flagging fortunes. A-list directors e sought: ironically, one of the first to cline is Barry Levinson, who decides to ake "Good Morning, Vietnam" instead. arty ("Beverly Hills Cop") Brest, on the ner hand, turns down "Good Morning,

and signs on for "Rain Man." HOFFMAN JUMPS ON BOARD: Now the big boys get involved. Mike Ovitz, head of the town's most powerful agency, Creative Artists, slips a copy of the script to his client, Dustin Hoffman, thinking he would be perfect to play Charlie Babbitt. But Hoffman is interested in Raymond. He'd seen a "60 Minutes" segment on a retarded savant iano player, and it had moved him to tears. So suddenly the script came and I thought, I love him, I want to play a savant." Barry Morrow is summoned to Malibu from his home in Claremont to meet with Hoffman, Brest, Birnbaum and Hoffman's old friend and adviser, the writer Murray Schisgal. Hoffman tells him tales of his days working in a mental hospital in New York when he was a struggling actor, then astounds the screenwriter with his announcement: When people look back on my career I'll be remembered for two roles: Ratso Rizzo and Rain Man. I want to do this picture, and I want to do it fast

CRUISE AND THE CLOCK: It's not so simple. M-G-M/UA is demanding the film for Christmas of 1987, and a directors' strike is looming: production will have to begin by April. Brest is feeling the heat, and his commitment is torn—he wants to make another road movie called "Midnight Run," and he is hoping to interest Hoffman in that project. But what has given the "Rain Man" project new urgency is the arrival of Cruise, who's gung-ho to act with his idol Hoffman. The two had met when Cruise went backstage to see Hoffman during his 1984 run of "Death of a Salesman," and the young star had stayed two hours.

"Hoffman, a ferocious perfectionist, felt a kinship from the beginning, recognizing a fellow workaholic when he met one. Cruise to the fellow workaholic when he met one. Cruise to the forduate" later confesses to Hoffman made "The Graduate" later confesses to Hoffman that he and Tim Hutton and Sean Penn used to sist toutside Hoffman's house in California, staring into his windows and daring each other to go up and knock.

Of course Cruise is two decades younger than the Charlie Babbit to fthe script. When

Of course Cruise is two decades younger than the Charlie Babbitt of the script. When Morrow objects to the casting, his days are numbered. Brest replaces him with writer Ronald Bass, a former lawyer who had written "Black Widow" and is known for his speed. With the strike looming, Bass—bedridden with chicken pox—has a mere two months to polish the script. Out go the loan sharks and the survivalists. In Bass's first draft, there is a happy ending when Raymond declares at a psychiatric evaluation that he wants to be with his brother Charlie: we last see them happily fishing together at the end of a pier.

ITS OFF: With time running out, Brest is off scouting locations in Chicago and Vegas and Flagstaff and, at Cruise's suggestion, another writer is brought in: The Color of Money" writer Richard Price. After 40 pages, Hoffman and Brest decide he's on the wrong track. They replace him with Michael Bortman "The Good Mother"! A further irony: executive producer Guber, fearing they won't make their start date, brings in a line producer for consultation. He chooses Mark Johnson, who has produced all of Barry Levinson's movies. He can't take the job at the moment, but the following year he will be "Rain Man's" producer.

Then, three weeks before shooting is to begin, UA chairman Tony Thomopoulos calls Guber with a deadly announcement: "It's off." Marty Brest has quit. His reasons are unclear, and he won't talk. There are some who believe Brest just decided the screenplay wasn't ready; others feel his decision had to do with Hoffman's growing insistence that the movie focus on character over plot; still others say the budgetary and scheduling pressures imposed by UA had simply become too much to bear. If this slapdash "Rain Man" hadn't worked, sugests one insider, the results could have gests one insider, the results could have

you're dead. That's called a career buster."
Brest's work on "Rain Man" wasn't for naught. When he shot "Midnight Run," it was filmed in many of the locations that he scouted for "Rain Man." And many people have noticed that both films' plots pivot on scenes in an airport: in "Midnight Run," when Charles Grodin throws a fit and refuses to fly; in "Rain Man," when Hoffman throws a fit and insists on taking a car.

been dire. "You fail with talent like that,

ENTER SPIELBERG: The man who had put the talent package together, superagent Mike Ovitz, was not about to see his work go

NEWSWEEK: JANUARY 16, 1989 53

anything but a conventional portrait. Photographs by Douglas Kirkland, *Newsweek*, January 16, 1989. (Originals in color.)

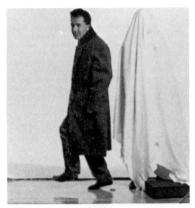

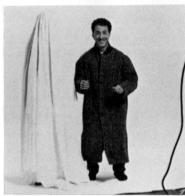

3. Dustin Hoffman was photographed with a Tom Cruise stand-in and vice-versa. Photographer Kirkland, commenting on the computer compositing process, wrote: "With this, just about everything or anyone can be put anywhere, making photography more and more dishonest—the probable direction of the 90s." Photographs by Douglas Kirkland from *Light Years: Three Decades Photographing Among the Stars*. (Originals in color.)

were in fact a continent apart? A journalistic publication would not tolerate a written article boldly asserting that two people were together when they were not.

In a later interview the picture editor explained that the two actors had wanted to be photographed together but could not do so because of scheduling reasons. They had, however, discussed the idea of the composite. Why not then say so and let the reader interpret the image on the basis of its not being a photograph but an image formulated long-distance? Or, more disquieting still, has it been assumed that people do not read photographs, do not need to know how to interpret them?

Photographs have been manipulated to deceive at least since the time of Hippolyte Bayard, who in 1840 staged his "Self-Portrait as a Drowned Man," a shocking image meant to redress the lack of attention to his photographic discoveries. In the 1950s Senator Joseph McCarthy, in his witchhunt for Communists, held up a photograph that created a national furor: two men were made to look as if talking privately to each other by simply cropping off a third. The Soviet Union has excised out-of-favor officials from photographs for decades. But thanks to the computer retouching has never been as efficacious or invisible an operation as it is now. Writers may have feared editors reaching inside their paragraphs to change their words, but until now photographers have not had to watch out for someone invading the rectangle of the image.

Now, by scanning photographs and translating them into digital information which can be read by a computer, one can modify an image with immense precision. Every pixel (the thousands or millions of tiny squares, "picture elements," which together make up an image) can be changed individually or all at once to another brightness and color (there may be as many as 16 million choices). The image can also be altered in larger ways: by adding or subtracting elements, increasing apparent focus, modifying lighting, or extending the image's borders. Unlike conventional retouching which may take hours or days of work by a skilled craftsperson, the changes can be effected immediately (within seconds or minutes) and more precisely controlled by the publication's editorial staff. They are also virtually undetectable.

This technology has long been used by NASA to mold a stream of data into a photograph representing outer space. Now it has become increasingly available for use in journalistic photographs as publishers' computer-based systems speed the preparation of text, pictures, and layouts to be transmitted directly to press. Since in this process photographs are routinely transformed into digital form, and can as a result be easily modified, editors face an ever-greater temptation to retouch them. Some seven hundred companies now own sophisticated computerized equipment that allows the modification of photographs, including twenty-five newspapers, and the number is expected to grow to one thousand five hundred companies in the next five years. Furthermore, as prices for the equipment dramatically decline (sophisticated systems were initially in the million-dollar range), and many of the capabilities of the early machines are transferred to personal computers (each New York Times photo editor, for example, is expected to have his or her own computer with a sophisticated image software program in 1990), potential problems become even more complex.

Of course, the use of such technology is not as immediately problematic in advertising or the arts as it is in journalism. If a smiling model in a liquor advertisement is given whiter teeth and a sexy companion, or if a photograph hanging in a museum features a green moon and a blue sun, there are not the same issues of accuracy and veracity that such retouching raises in journalism or other documentary uses of the photograph.

The fact that many highly respected journalistic publications have in recent years taken to modifying photographs has provoked considerable discussion and consternation. What certain editors and art directors find appropriate, other professionals and readers will not. As Guenther Cartwright, a professor at the Rochester Institute of Technology who has purposefully altered photographs to provoke discussion, has put it, "One person's enhancement is another person's alteration."

Perhaps the most famous case—both because it occurred relatively early and has been talked about a great deal in photojournalistic circles—is the 1982 *National Geographic* cover of the pyramids of Giza.⁴ In this case a horizontal photograph was made into a vertical image suit-

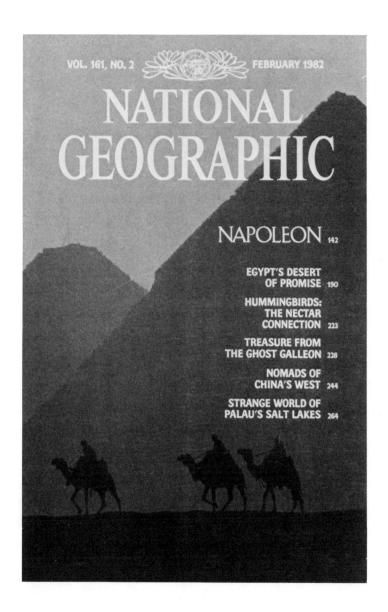

4. In this early example of computerized retouching, a horizontal photograph was made to fit the magazine's vertical cover format by electronically "pushing" the two pyramids closer together, a process the editor referred to as a kind of retroactive repositioning of the photographer. Image by Gordon W. Gahan (can one still write "Photograph by . . . ?"), *National Geographic*, February 1982. (Original in color.)

5. "One person's enhancement is another person's alteration." This fake, miniature-sized *National Geographic* cover was fabricated to stimulate a discussion among press photographers on the ethics of such manipulation. Cover assembled by photography professor Guenther Cartwright and printing specialist Blair Richards, using photographs made by Cartwright and White House staff photographer Bill Fitzpatrick. (Original in color.)

able for the cover by electronically moving one pyramid closer to the other. While Robert E. Gilka, at that time the magazine's director of photography, referred to the introduction of such techniques as "like limited nuclear warfare. There ain't none," the *Geographic*'s editor, Wilbur E. Garrett, disagreed. He referred to the modification not as falsification but merely the establishment of a new point of view by the retroactive repositioning of the photographer a few feet to one side (figure 4).

The *Newsweek* modification makes clear that elements within a photograph can no longer be assumed to have occupied proximate space; the *National Geographic* example shows that a photograph is not necessarily time specific, but a kind of photographic time travel is now possible. The "decisive moment," the popular Henri Cartier-Bresson approach to photography in which a scene is stopped and depicted at a certain point of high visual drama, is now possible to achieve at any time. One's photographs, years later, may be retroactively "rephotographed" by repositioning the photographer or the subject of the photograph, or by adding elements that were never there before but now are made to exist concurrently in a newly elastic sense of space and time. The "decisive moment" may refer not to when the photographer took the picture, but when the image was modified.

There are a number of instances that have come to light, and undoubtedly many that have not, of editorial modification in the mainstream media. (The overtly sensationalistic press, with photographs of two-headed men and the like, is not being discussed here.) On the cover of one issue, *Rolling Stone* magazine, for example, reduced the violent content of the image by using the computer to remove a shoulder holster and pistol from the photograph of one of the stars of the television program *Miami Vice*, Don Johnson (figure 6).⁵ (Perhaps a more militaristic publication would have decided to upgrade his pistol to a submachine gun.) The editors of the bestselling book *A Day in the Life of America*, billed as a look at this country "by 200 of the world's leading photojournalists on one day," found that even with more than 235,000 images to choose from, the realities of marketing overcame the frame of the photograph. Like *National Geographic*, they shifted elements to make a horizontal photograph fit into the cover's vertical space.⁶ The

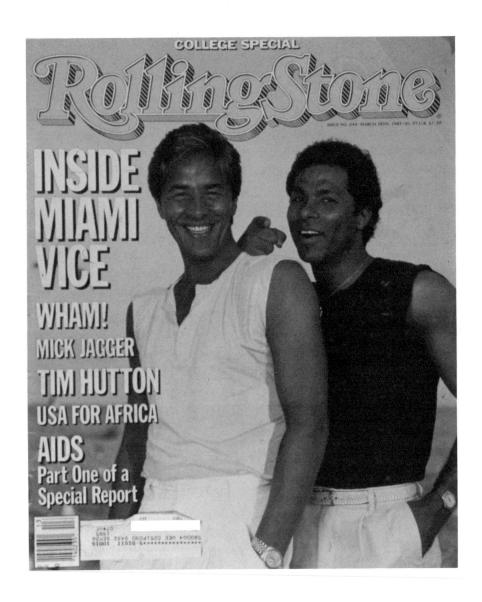

6. In pursuit of a less violent cover image, the shoulder holster and pistol actor Don Johnson (left) was wearing were electronically removed. Image by Deborah Feingold, *Rolling Stone*, March 28, 1985. (Original in color.)

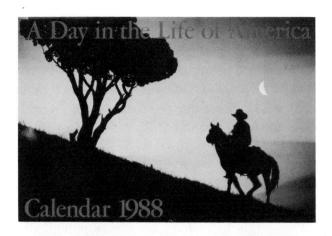

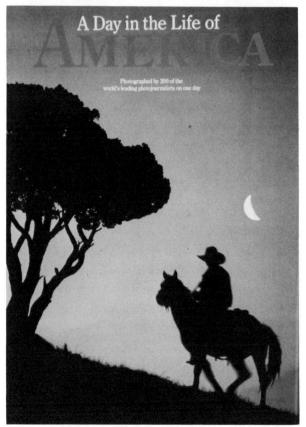

7. Despite having more than 235,000 photographs to choose from, the cover image of the bestselling *A Day in the Life of America* was electronically retouched from a horizontal photograph into a vertical image, "literally slid[ing] the tree down the hill," according to an editor. The calendar's cover is the horizontal version of the same elastic image. Images by Frans Lanting. (Originals in color.)

book's editors, who have defended the tampering as legitimate in a commercial world, did not attempt to keep their manipulation a secret: they then published the corresponding horizontal photograph (or at least a horizontal photograph, since one feels increasingly unable to assert that an image has emerged unaltered) on the cover of the *A Day in the Life of America* calendar and the vertical image on the calendar's back cover (figure 7).

Indeed, many editors apparently feel that photographs can be retouched as long as they are not news photographs and "common sense" is employed. What might be called "reverse cropping" (the new technology requires a new vocabulary), or the enlargement of a photograph on one or more sides by using the computer's ability to quickly clone sky or another element, is probably the most pervasive electronic retouching technique. Many newspaper picture editors seem to be in accord that photographs on food and fashion pages can be retouched without informing the reader. As Robert F. Brandt, managing editor of Newsday, one of the nation's top newspapers, recently put it in the journal presstime: "We're a lot freer with feature-section design presentation than with news presentation. A double-truck spread in the food section in which clams and oysters are moved about for effect is not going to create a major ethics debate at our paper. We're a lot less free with the live news photo on the news-section cover."

The implications of the new technology do not necessarily frighten editors. Hal Buell, Assistant General Manager of Newsphotos at the Associated Press, known for its early use of an electronic darkroom, has asserted that "Ethics is in the mind. It is not in the tools you use." Similarly, Brandt wrote: ". . . the potential for tomfoolery lurks no more dangerously at the computerized graphics and pagination device than with low-tech equipment of the past."

Brandt continues: "During the introduction of the Scitex [a company which makes computer graphics systems] equipment at *Newsday*, senior editors constantly discussed whether a new code of ethics was needed to outline its proper use—and more appropriately, its improper use. So far, those discussions have led only to these 'don'ts' at *Newsday* [referring in part to the examples mentioned above]: Don't move pyramids. Don't remove Don Johnson's pistol. Don't do anything to make the managing

editor look stupid." He continued, "We have one 'do': Show the page to the appropriate editor before it moves."

Brandt is unconcerned by retouching such as "extend[ing] sky and other background to allow a type overprint." His rationale: "How many times have you returned to the photo lab to see if a negative had more image area such as the sky for overprinting?" Now one no longer has to see if more sky exists, but can simply add it. Or, another example: "We've colorized black-and-white photos. Gasp! The general rule is to execute such modifications in an obvious fashion, so the reader is aware of them. At times, when we felt the need, we have credited the Scitex operator for colorization. Please don't get the idea this is all routine. But when the Beverly Hills Hotel's facade adorned Newsday's feature section cover, it was colored to its known pinkish cast and in all its artdeco splendor. The plan was to make it look '1930s post-cardy.' The editor insisted that this must be clear. It was. It was clear to all but the extravagantly literal that it was not a true photo." As always, the final response, he writes, will be that "smart editors, smart designers and smart Scitex operators will consult or bounce the toughest calls up to higher management."

The tools are so efficient and available, however, that editors (to say nothing of readers) are not always aware of their use. For example, at one California newspaper a staff member automatically corrected what was perceived to be an error: red water in a swimming pool. The resulting change of color to blue unfortunately contradicted the point of the photograph, which was that someone had been putting red dye into the water. In a similar instance, at *The New York Times Magazine* an employee in the printing plant, without asking permission, is said to have added some bushes to fill in a blank space in a photograph. This modification came to light only because I was writing an article to be published in the same magazine on this subject. The editors said that such modification was contrary to *New York Times* policy.⁹

In another newspaper mixup, and somewhat ironically, the *St. Louis Post-Dispatch* altered a photograph illustrating the awarding of the Pulitzer Prize in photography, removing a can of Diet Coke. *The New York Times* reported: "Because of a misunderstanding between editors, *The [St. Louis] Post-Dispatch* altered a photograph of Ron Olshwanger, an

amateur photographer, taken the night he was awarded a Pulitzer Prize for spot news photography. Using old techniques, the picture would have been cropped, or cut to eliminate the can, a standard practice in photojournalism. But through an electronic imaging system manufactured by the Scitex America Corporation, the can was lifted from the picture electronically and replaced with images reproduced from surrounding background." The following week the newspaper's management declared prohibitions on the use of its Scitex machine, forbidding the moving, elimination, or addition of elements in news photographs, and requiring that the managing editor approve any application of the computer to photographs that accompany feature stories. They also stipulated that major changes be indicated in the credit line.

Evidently, editors do not always understand the effect of such alterations on the reader. Such was the problem at Time magazine, as recounted by former picture editor Arnold Drapkin: "When you get very close to something," stated Drapkin, "you sometimes can't see what you're really doing. We had a lead story about the Marine espionage case in the [American] Embassy in the Soviet Union. What do you do for an illustration? How do you open with a dramatic lead? We got this wonderful idea of doing an interpretive photograph. We all knew that we were putting two pictures together. We took a picture of the Embassy, and then we got a Marine and photographed him in a studio with the right light. It was obvious that it was put together as two different pictures. We even ran the two credit lines. Yet, it never occurred to us to caption this as a photographic illustration because we all knew it was a photographic illustration." After receiving a number of letters, Drapkin wrote back to complaining individuals apologizing for the composite. Perhaps letter-writing is after all a way for the reader to influence the course of future events. The director of photography at National Geographic, Thomas Kennedy, referring to the controversial retouching at the magazine, has asserted that "There was so much negative fallout that we'd be extremely reluctant to do that again."12

And what of photographers who mislead editors, intentionally or not? For example, a couple of years after featuring a cover photograph of the Australian outback by a photographer known for his advertising work, *The New York Times Magazine* published a correction explaining that

they had only recently found out it was a composite of two images (although in this case the retouching was done conventionally). As more photographers have access to computers, and as the advantages of image manipulation become apparent, how will editors be able to detect what really is an original image? Peter Howe, director of photography at *Life* magazine, recently declared, "If you've got a photographer who is sending you a series of electronic impulses which as photo editor you bring up on the screen of your electronic workstation, and it is showing a massacre in Burma—there is absolutely no way you know whether that massacre took place." ¹³

Despite the problems, the computer has become an integral part of publishing, as was recently signaled by photojournalism's former flagship, Life. In an issue entitled "The Future and You," which featured a picture of twelve models in the studio electronically multiplied to make what they referred to as 12 million people standing in a desert (although there seemed to be many fewer), Life informed the reader, on the publisher's page, of this and other changes in photographic images, and promised more to come (figure 8). "We are accustomed to seeing a painting in expressionistic colors, but we think of photographs as being real and representational," design director Tom Bentkowski was quoted as saying. "As it becomes easier to manipulate the colors electronically, we will see more and more of that being done in the future." As an indication of the degree of deception possible, the issue featured a composite picture said to be from three photographs—one of a model wearing a blond wig to look like Marilyn Monroe, one of a television set and another of a living room—whereby Monroe seems to be walking out from a wall-size television that glows.14

This kind of manipulation apparently is not confined to the print media. Ben Blank, Art Director of ABC-TV News, was quoted in an article by Roger Armbrust in *Computer Pictures* magazine: "There are so many things that can be done on the Paint Box [an electronic retouching system] to help clean up a picture. If the President, for example, is in a press conference and there are 12 microphones in front of him, you eliminate them." He continues: "There's no real concern about putting figures where they aren't as long as you don't alter the news itself." A certain sense of fair play is invoked in recounting what occurred dur-

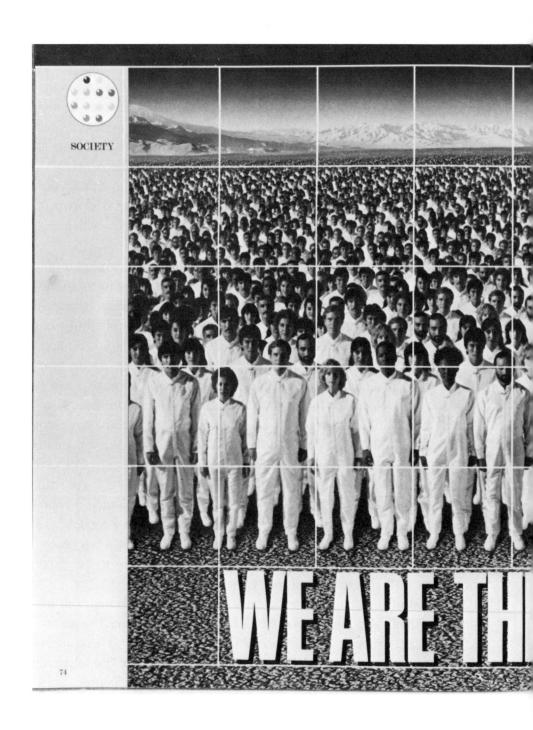

8. Attempting to illustrate the world's racial makeup in the year 2025, *Life's* editors hit on the idea of using a studio photograph of a dozen people and replicating them electronically in sufficient quantity to make their point. The readers were informed of the strategy. The image is

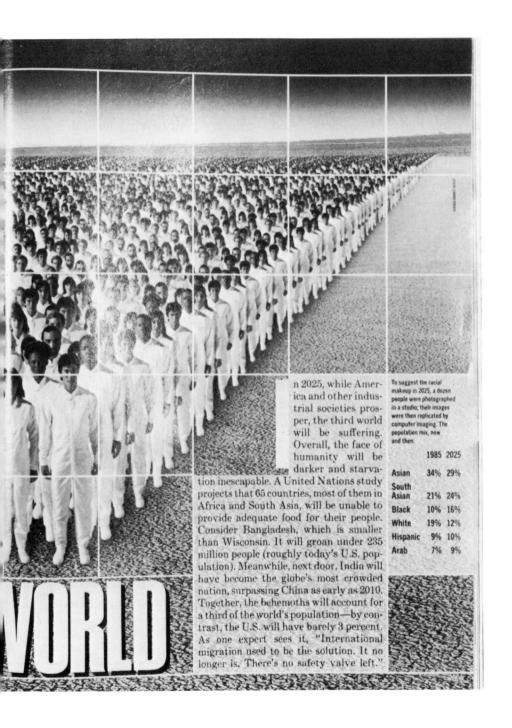

credited on-page to John Zimmerman, and elsewhere the graphic paintbox art is credited to Henry Baker. (Original in color.)

ing the 1984 presidential election campaign: "If the head and shoulders are hunched up, we work on cleaning up the suit. Take Mr. Reagan: If he's hunched over, we can clean that up—straighten out a shoulder. We do things like that. It's cosmetic. And we do it equally. What we did for Mr. Reagan, we also did for Mr. Mondale." Although he does go on to say that "we wouldn't retouch the person," he adds that having contacted the headquarters of Congressional candidates for photographs "they sent us black and whites. We colored them."

Computerized compositing and simulation techniques may have many other uses in a television news environment in which an NBC producer can describe the re-creation of events as the "natural next step in broadcast news." ABC's *World News Tonight* recently took this "next step" to reenact alleged spy Felix Bloch passing a briefcase to a Soviet diplomat, and both NBC and CBS plan to broadcast prime-time news programs that will rely on such simulations. It would not be surprising if network producers, tired of using actors to play the roles and searching for higher ratings, employed computerized imaging techniques so that the viewer could "see" a real scene reenacted: a computer-generated Felix Bloch could then appear to pass the briefcase himself.

As I conclude this chapter, I am informed by word of mouth that in a later issue of *Newsweek* magazine, published some two and a half months after the *Rain Man* article, *Newsweek* again modified a feature photograph, this time a cover image illustrating "Mickey's New Magic: Disney World Unveils a \$1 Billion Movieland." A cartoon version of Mickey Mouse, standing next to two wide-eyed children staring into a crystal ball, was inserted after the fact to replace a man who had been photographed there in a Mickey Mouse costume. A minor manipulation? In any case, the photographer was not consulted.

MODIFYING NEW YORK'S SKYLINE

To demonstrate the graphics capabilities of the computer, I wanted to modify an image subtly, one that on first look would appear to be just another photograph. Obvious alterations would be noticed immediately; the idea here was to show changes that would make a photograph unreliable, but not so obviously unreliable that it would be immediately rejected.

Using a Scitex Response System at the company's Massachusetts headquarters, we used a scanner to digitize a photograph of New York City's skyline. This basically means that we quickly transformed the photograph pixel by pixel into numerical form so that the computer could work with the image. With 16 million colors to choose from for each of thousands of pixels, the system offers a luxury of choices and extraordinarily precise retouching. Then we scanned in three other photographs: the Eiffel Tower, the Statute of Liberty, and San Francisco's Transamerica Pyramid.

We called up the photograph of New York's skyline on the computer's screen to see where to put the image of each structure. On an athletic field we found room to "land" the Statue of Liberty. We enlarged that section of the cityscape on the screen and placed the image of the Statue next to it. Using a computer control with a crosshair on one image and a circle on the other, the Scitex operator rapidly copied the information from the image of the Statue to the athletic field. Then he used another tool to smooth out the base of the Statue so that it would look more natural in its new environment.

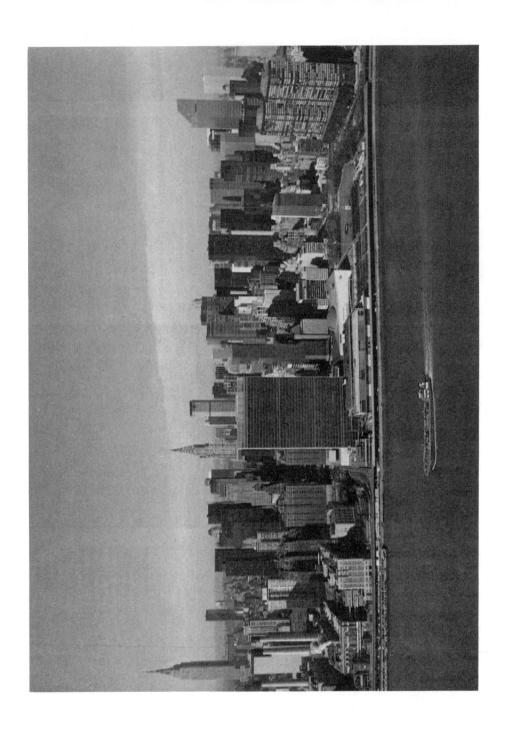

9. A photograph of the New York City skyline. Photograph by Gianfranco Gorgoni. (Original in color.)

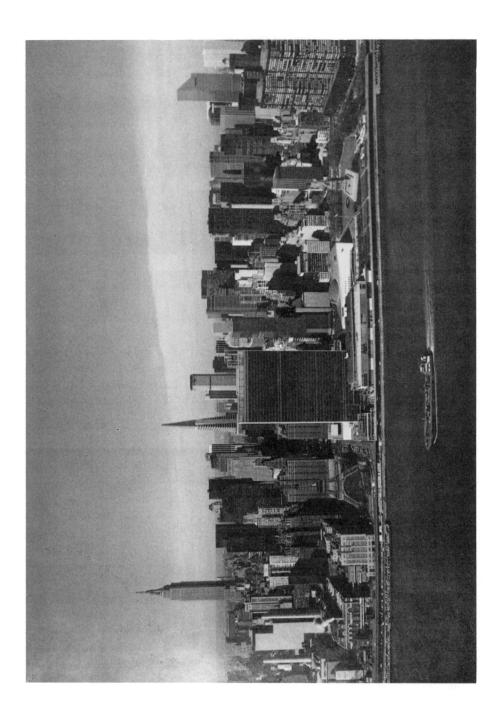

A composited image of the New York City skyline with the electronic addition of San Francisco's Transamerica Pyramid, the Eiffel Tower, and the Statue of Liberty. Photographs by Gianfranco Gorgoni (skyline), Jean-Pierre Laffont (Statue of Liberty), Jean Claude Lejeune (Eiffel Tower), and Steve Proehl (Transamerica Building). Image by the author with the assistance of the staff of the Scitex America Corporation headquarters, Medford, Massachusetts. (Original in color.)

Similarly, we transferred part of the photograph of the Eiffel Tower, but not before "destroying" another structure to make room for it. Having put the Eiffel Tower in New York, it seemed like a reasonable decision to create a traffic jam around it—accomplished easily by using the same technique to clone cars from the original image of the cityscape and place them in a variety of positions around the Tower.

The Empire State Building was moved uptown a few blocks, and made taller in the process. (The operator suggested that as long as we were moving it, we might as well do something else to it as well. The temptation with such a machine is to keep making changes, because they are so easy to do.) Next to the new structure we ended up with the remains of the former building—a flattopped Empire State Building.

We made other changes: replaced the Chrysler Building with the Transamerica Pyramid, added a pier, removed a smokestack, spun around the top of the Citicorp Building. All of this was accomplished in a few hours (much of the time taken up with trying to decide how the structures would look best together), and by the end of the afternoon we were ready to transmit the new image directly to press.

I felt like a deity, able at will to move massive structures, or at least their representations. The irony struck me when flying back to New York that same day and traveling home from the airport. New York and its skyline seemed somehow less real, more arbitrary, less comfortingly solid than before. I had become, in a sense, more powerful than its largest buildings, able to move any of them at will—an ephemeral talent with extraordinary implications.

These images first appeared accompanying the article "Photography's New Bag of Tricks" in the *New York Times Magazine* (November 4, 1984).

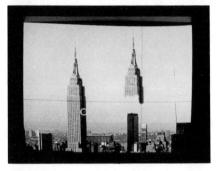

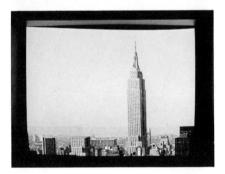

In minutes the Empire State Building was moved uptown and made taller by using a control on the Scitex Response System that allows the operator to immediately copy an image from one part of the frame to another. Photographs by Sarah Putnam. (Originals in color.)

Computers Don't Kill People

IT WOULD BE WRONG to lay the blame for the dubious veracity of photographs solely on the new technology, as no doubt a chorus of voices will attempt to do. Editors of contemporary publications, as well as politicians orchestrating "photo-opportunities," understand more than ever before how to borrow from the photograph's perceived authority while at the same time manipulating imagery in the service of their own needs. Photographers are too often willing accomplices to these strategies. This has helped to create a climate in which photojournalism, the timely reporting of people and events, has been to a large extent subsumed within what is now often called "editorial photography." In this approach the illustration of preexisting ideas is emphasized, a task for which electronic retouching techniques are particularly well suited.

In photojournalism's earlier days computer retouching techniques would have been less useful. Journalistic photographs could remain somewhat visually awkward; the medium was considered more a vehicle for the exploration of a largely unknown world, to be brought dramatically and viscerally into the reader's living room. At that point the world remained mostly unseen, and its unveiling through photography was expected to motivate a large readership. As its founder, Henry Luce, put it, *Life* magazine was created in 1936 "To see life; to see the world; to eyewitness great events; to watch the faces of the poor and the gestures of the proud; to see strange things—machines, armies, multitudes, shadows in the jungle and on the moon; to see man's work—his paintings, towers and discoveries; to see things thousands of miles away, things hidden behind walls and within rooms, things dangerous to come to; the women that men love and many children; to see and to take pleasure in seeing; to see and be amazed; to see and be instructed;

thus to see, and to be shown, is now the will and new expectancy of half mankind."

The first issue of *Life* magazine was an enormous success at the newsstand, selling out all 466,000 copies at a dime apiece. Readers could peer into the lives of workers in America's northwest as they "make whoopee on Saturday night" and view the monumental dam they built, featured on *Life*'s cover, or go abroad in the "Camera Overseas" section to a variety of European countries. Pursuing the famous, the magazine published four pages of photographs on the "Greatest Living Actress," Helen Hayes, and also ran a Presidential photo album. Beginning to explore another unknown territory, one formerly kept private, the magazine opened with a dramatic photograph of a newborn baby upside down, entitled "Life Begins."

One of the prime subjects for photographic exploration has always been the dramatic moments of life, and nothing has been seen as more dramatic than war. Beginning in the nineteenth century during the Crimean War and the American Civil War, photographic coverage of war continued in the newly inaugurated mass picture magazines during the Spanish Civil War, which broke out in 1936. Taking advantage of the manufacture of more portable cameras and light-sensitive film, which made it possible for photographers to focus on the action rather than its quieter, more static aftermath, the magazines stressed the direct, close-up nature of their photographs.

For example, England's *Picture Post* headline for an 11-page 1938 Robert Capa story on the Spanish Civil War was a simple declarative "This is War!" It asserted the power of photography to increase the reader's proximity to far-away events. The captions were filled with enthusiastic, nearly breathless comments on the new world opening up ("You can almost smell the powder in this picture," stated one caption). One rather quiet image of a few soldiers sitting under an overhanging rock with some smoke lingering in the background was titled "The Most Amazing War Picture Ever Taken." The caption goes on to explain: "This is not practice. This is war. These men crouching beneath the ledge feel the shock of every shell-burst. They know that a better aim will bring their own piece of rock down on top of them. They know that in a minute's time they may be ordered forward over

the shell-swept ground. They are not worrying. This is war, and they are used to it "(figure 10).

In today's overheated media climate, however, this picture, and many quieter, more empathetic images, would no longer be published. In part this is because over the last fifty years much of the world, including its wars, has been seen so often, both in still images and on television. Today's editors have raised the visual stakes, while at the same time decontextualizing the situations depicted. Although war has always been considered an example of what Wilson Hicks, *Life* magazine's early executive and picture editor, called a "self-contained and well-paced drama" whose "crises come put up in handy packages," one difference today is that newspapers and magazines publish a continuous stream of generally interchangeable images of violence's apex, milking it for its realism without an exploration of its unfolding or underlying causes.³

Violence is epidemic and everywhere the same, a voyeuristic, supercharged form of entertainment lacking specific causes or roots in the cultures and people from which it comes. Violence has become an aberrant spectacle that the reader is encouraged to watch from afar. One thinks of how irrational and "Beirut-like" the United States also would appear if its street violence alone were depicted.

Why is violence portrayed this way? Many photographers say the marketplace demands images of "bang-bang." As a result photographers from various countries on assignment may live together in a hotel in Jerusalem, go out daily in search of instances of conflict, but are unable to explore the reasons for the *intifada* in the West Bank and Gaza because no publication will pay them to do it. One foreign photographer who lived in San Salvador for several years said that he began by trying to devote every Sunday to covering something other than hot news, exploring the daily life of the people, trying to put the violence into context, but had to give it up after only a couple of tries because he was always on call to cover the latest event. Similarly, the editors of the 1983 book *El Salvador* found that, even with the work of thirty photographers to draw from, there were not enough images that delved into the daily lives of the country's inhabitants, so insistent and repetitive were the publications in their assignments.⁴

Emblematic of such repetition are two spreads that appeared in Time

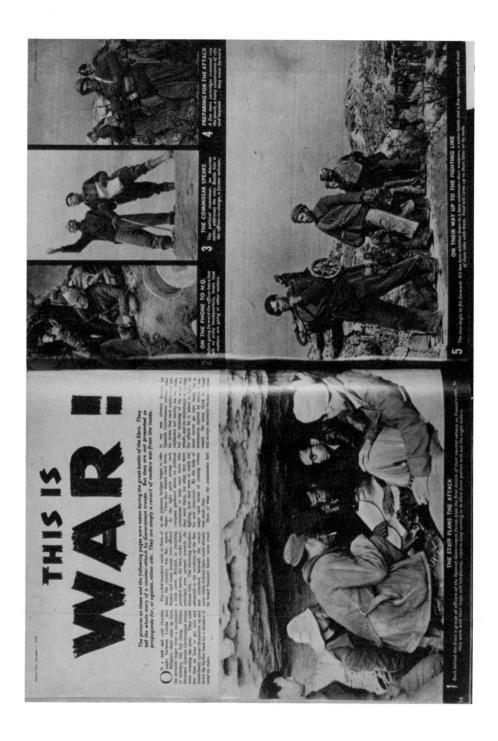

10. A "self-contained and well-paced drama" is how *Life* editor Wilson Hicks described war, whose "crises come put up in handy packages." Robert Capa, "This is War!," *Picture Post*, December 3, 1938. (Original article 11 pages.)

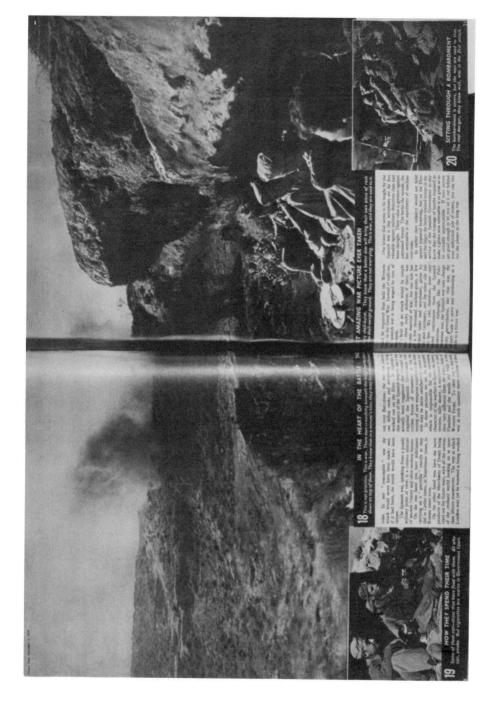

and *Newsweek* the same week depicting a meeting between opposition leaders and the head of the government in El Salvador. The two reports virtually mimic each other: in headlines ("Giving Peace a Chance"; "Does Peace Have a Chance?") and in images, even though the seven photographs are by four different photographers. In each spread one sees President Duarte with a megaphone facing the opposition leaders with their megaphones, and a popular march in the streets, illustrating the problem of pack journalism whereby all photographers must point their cameras in the same directions (figure 12).⁵ This comparison also points up the tendency of publications (although few examples are as extreme as this one) to use photographs according to a formula that rarely allows for the less predictable exploration of the issues behind the conflict or event.

Yet another profound change has come to photojournalism. For a long time documentary photographers have fulfilled the role of society's witness, bringing war and other events to the reader. John Szarkowski, the Museum of Modern Art's curator of photography, asserted that "During the first century of his existence, the professional photographer performed a role similar to that of the ancient scribe, who put in writing such messages and documents as the illiterate commoner and his often semiliterate ruler required."

It was a largely amicable relationship. For example, *Life* had twenty-one photographers on its staff covering World War II and the editors chose pictures that generally empathized with the American cause. GIs were shown to be gritty and human. The atrocity of war was down-played. Reality was sent back to the United States censored (there was strict military censorship) and was then "appropriately" packaged. For the most part, the way the war was seen in *Life's* photographic coverage was similar to the way other human endeavors were represented—from the perspective of the American way.

But the Vietnam War changed photojournalists' function. Their relationship with society and its power centers was no longer as friendly. Photographers, like journalists generally, began to be viewed as powerful adversaries as their reports and photographs veered from the government's official assertions. There were too many conflicting points of view presented for photographers to be considered naive, trustworthy

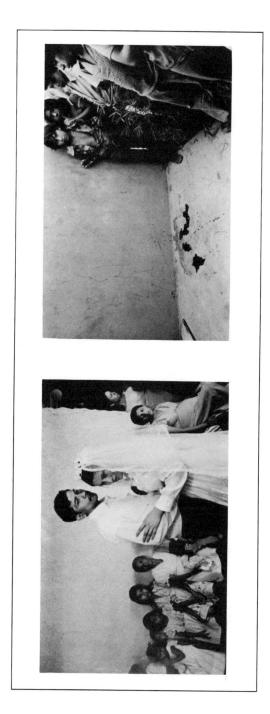

11. The daily life of people in a "combat zone" is often overlooked, and violence is shown as occurring in a voyeuristic vacuum. The book *El Salvador* set out to be an exception. Photographs by Susan Meiselas, from *El Salvador: Work of Thirty Photographers*, 1983.

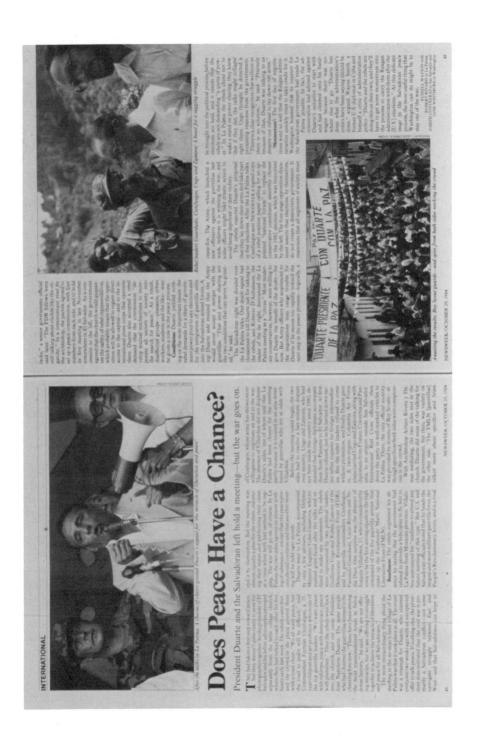

12. There is a formula in photojournalism that leads to a repetitive emphasis not only on similar events but also on the same aspects of those events—even when, as in these two examples,

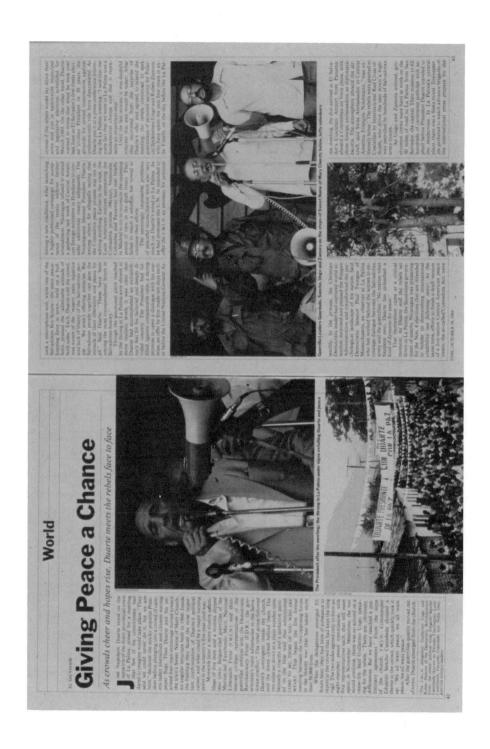

work from several photographers is used. Newsweek and Time, both October 29, 1984. (Originals in color.)

scribes following society's dictates. Photographers, and their colleagues in television, supplied images that contradicted official thinking and challenged the legitimacy of the American-sponsored war—a little girl running from napalm, a Buddhist monk self-immolating, a member of the Viet Cong being summarily executed, a grieving widow crying over an anonymous body bag. And instead of authenticating American ideals—like the photographs taken of heroic soldiers on D-Day or of the flag raising at Iwo Jima—many of the photographs from Vietnam asserted a disturbing, even radical, point of view.

But just as journalists gave the public a powerfully different way of looking at the war, and were contributing to the downfall of American leaders over Vietnam and Watergate, the mass-circulation, general-interest picture magazines were going out of business, and photojournalism was losing its most impressive forum. In this country the large picture magazines were replaced by a variety of specialty publications, while many local newspapers took a greater interest in expanding their own usage of photographs.

Rather than take on the world as their subject matter, as *Life* did, the new magazines fundamentally narrowed their world view. I remember Paul Stookey, a singer with the folk group Peter, Paul and Mary, ruminating at a concert on how after the demise of *Life* the next popular magazine was titled *People*, leaving out a good part of "life," and then there was *Us*, which excludes a large part of "people," and then we came in more recent years to *Self*, which excludes almost anybody and anything else. The next major publication, according to his logic, would be called *Me*.

Following the assertive, conflicting voices of that period, when many readers and journalists alike felt implicated in events depicted, greater corporate control was exerted on publications. In a new age of omnipresent market surveys and with the failures of mass magazines such as Life, Look, and The Saturday Evening Post, publishers began to prefer the known and controllable, in part to target specific audiences attractive to advertisers. Editorially, they chose the upbeat and upscale, confirming the reader's sense of optimism and reinforcing the consumer values of America. To this end pictures were used to create what one advertising director referred to as "a good environment for advertising." Per-

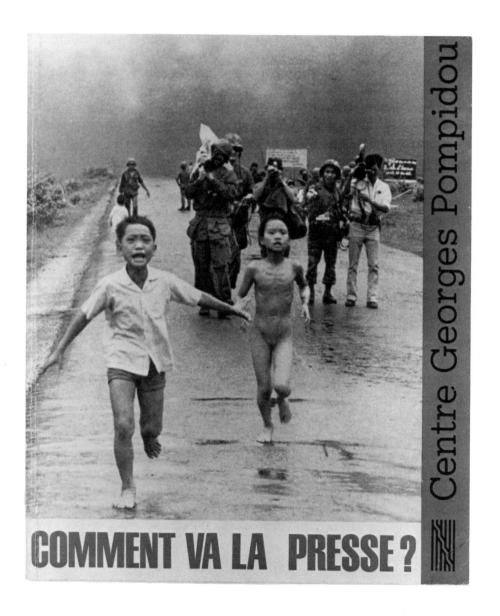

13. According to *Time*, a photograph of these children was "called a fake by General William Westmoreland, who suggested the girl in the picture was burned 'in a hibachi accident.' " Photograph by UPI from the cover of *How Goes the Press?*, published by the Georges Pompidou Center in Paris.

haps exploration was also deemed insufficient because publishers thought that world-traveling readers were themselves beginning to see and take pictures of much of what was out there or were being deluged with imagery from television and elsewhere. Or maybe reality was simply judged to be too disheartening.

As photographs were found to liven the personality of publications and attract advertisers, editors began to select images that appeared more sophisticated, more the work of specialists, and more about the unattainable. Readers and advertisers were made to think they were getting something special—and the exotic could be reinvented.

In any case, the ambiguities and subtle questionings of the photograph were eschewed for a more controlled format, and editors from outside photography began to better understand how to both assign and select photographs. As a result, and partially for budgetary reasons, photographers were sent on shorter assignments—for a day when previously they might have been sent for several days or a week. The photographs, as always, were being molded to the personality of the publication, but this time the editors were placing greater emphasis on what one might call the prerequisites of the publication's self over the requisites of outside life.

As a result of these trends today's pictures, particularly those in magazines, tend to overpower human vision rather than resemble it. They are more theatrical, better lit, sharper, and more highly colored than seeing itself—qualities well suited to the capabilities of electronic retouching systems. Whereas in the past, photographers were encouraged, to some extent, to spend time exploring and articulating what they uncovered, now it is mostly for the stalking of celebrities or the apocalypse of violence that one spends much time. The readers, given diminished opportunities, are less likely to feel that they are discovering a scene in all its detail with the help of the surrogate photographer, and as a result they have less freedom to interpret imagery according to their own predilections and experiences.

The staging of photography is not new, but formerly, when photographers would set up a photograph, they would be encouraged to match what would normally have happened, as opposed to contradicting and transcending it. Wilson Hicks of *Life* magazine writes on the subject in

his 1952 book *Words and Pictures:* "A majority of picture stories of a nonspontaneous character require a certain amount of setting up, rearranging and direction. In dealing with them the photographer's purpose is to recreate an actuality in substance and in spirit in such a way as to make clear the ideas which the photographs are intended to convey and to give coherence to their compositions."

He goes on to describe how this was orchestrated in W. Eugene Smith's classic 1951 photo essay, "Spanish Village," which has been referred to as the greatest photo essay *Life* ever published.

"Life in the village was not a series of acute, ready-made crises; except for the death of a patriarchal old man, it was, on the surface, routine. But beneath the routine was a continuing and passive tragedy of primitivism and poverty. This was the story's theme; Smith's problem was how to develop it most vividly and dramatically in pictures. The everyday actions of the villagers were casual, and if on this assignment Smith had 'faded into the wallpaper,' his pictures would have been casual, and indifferent too. By explaining to the villagers that he wished to tell who they were and what they did in the most interesting possible manner, and to draw the full import and most suggestive meanings from their actions and appearances, Smith made actors of them, but actors in a drama held strictly to the facts. For the camera they enacted consciously what they theretofore had done unconsciously; they did what they were used to doing better than they were used to doing it. In re-creating an actuality, Smith gave to it more power and beauty than it had originally."

While it is questionable journalistic ethics to ask people to do "what they were used to doing better than they were used to doing it," one has a sense that the photographer was trying, in some sense, to get at the essence of the people being portrayed, albeit in this case from a personally romantic point of view. By contrast, today's directed, posed, or set-up photographs, while having abundant precedents (no magazine ever just used photographs to explore the world, and *Life* was not by any means an exemplar of journalistic purity), are striking for their large-scale, skillful avoidance of and even retreat from an investigation

of the deeper strains of life under a thick veneer of strobe lights, dramatic posturing, and formularized approaches. People are generally not asked to re-create their lives to get at the core but to make their lives conform to the prevailing fantasies the publication cherishes. Many photographers, caught up in the cult of personality, seem at times to consider themselves and the publications they represent more important than the people they are setting up to photograph.

In today's posed photographs people are made to do things that they are not used to doing—a successful bank president might throw money into the air, for example, or pose clothed in gold. Photographs are manufactured rather than elicited, and people are made into powerful cartoon characters. They are then entered into a magazine-sponsored drama that, to a sizable extent, has fame as its currency and power as its foundation.

In part, this editorial trend appears designed to keep up with the look of advertising photography, which often seems as "real"—only more cleanly composed, livelier, better lit, and even more self-consciously photographic. Such advertising-inspired imagery allows a publication to compete with the visual impact of the commercial imagery and at the same time project a safe, palatable image for itself. As an article in *The New York Times* recently asserted: "In many respects, magazine publishers have come to see their job as delivering a market to advertisers. The more tightly focused an audience the magazine can reach, the more efficient it becomes as a delivery vehicle."

I remember once showing the editor of a major newsweekly a grim, gray, smoky color overview of the victims of an explosion in a picnic area—and being asked whether I did not have another image of the same scene with brighter colors. Or, to take one example from *Life* magazine, I think of an image of a minister portrayed for his work in fighting the dangers of the nuclear bomb. ¹⁰ Shown riding down a country road perched on a white horse in an image lit as if for the movies, one immediately understands that the man has been enlisted in the theater of the current media (figure 14). It seems that even in a journalistic publication the enormity of the implications of the bomb are less important than placing the minister in a cinematic fantasy, one in which he is undermined as a Don Quixote figure.

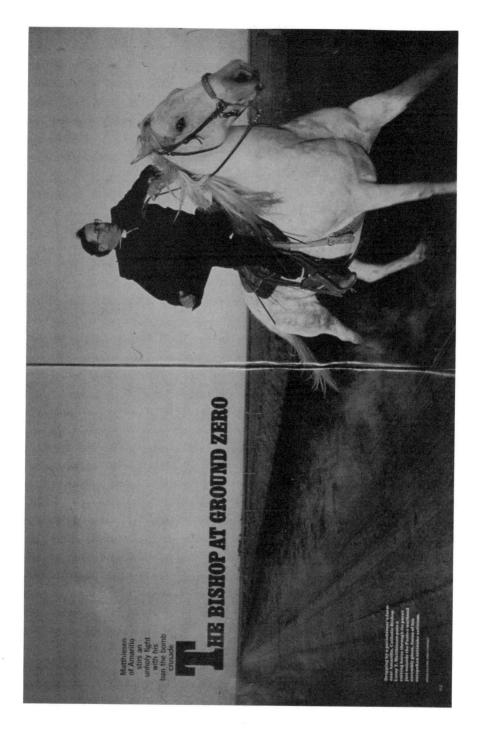

14. There seems to be a requirement to make people "more" than they normally are in magazine photographs, which often means conformity to a cinematic, upscale fantasy even when, as in this example, the issue is nuclear war. Photograph by Douglas Kirkland from *Life*, July 1982. (Original in color.)

Another tendency in editorial photography is that of employing preexisting images as simple-minded support for the point of view of the more articulate text. If, for example, the text says that George Bush has recently succeeded with certain initiatives, he will be shown smiling at the White House. If he is said to be in serious trouble, an image will be chosen in which he looks troubled. A photographer will not be asked to investigate Bush's true state; his or her images will be used as stick figures to "prove" the text's point (not unlike what was done in *News-week*'s Cruise-Hoffman composite). Newspaper readers are confronted daily with photographs of the President that for the most part simply repeat that he is alive, not informing but invoking Presidential authority on the publications' pages.

Further indicating the constriction in photographic seeing, the picture essay has largely disappeared from the pages of magazines. It is much harder to control a group of images, to direct their multiple meanings. The picture essay is a form that allows photographers to develop a sustained and deepening narrative while establishing their own point of view. Its disappearance aids in the decontextualization of photojournalistic imagery and in their loss of integrity and strength, factors which help to make electronic retouching a more likely choice.

Speaking in 1987 in a forum on the future of photojournalism, I criticized *Life* for not having sufficiently addressed the issue of drug addiction in this country, our "number one" problem, particularly since the United States government had declared a "war on drugs" and Army intervention was being discussed. I asked why one had to go back over two decades to find the last memorable photo essay on the subject to appear in the pages of the magazine. Later, I was informed that *Life* had recently published an essay on the subject which I had seen but had evidently not made an impression on me. Looking at the differences between this essay, on cocaine addiction, and the 1965 essay on heroin addiction to which I had referred, illuminates the trend in magazines away from reality. It also points to the necessity of reading photographs, not just the text surrounding them.

Headlined "'I Am a Coke Addict': What Happens When Nice Guys Get Hooked," the cover image is of a young man smoking a cigarette-

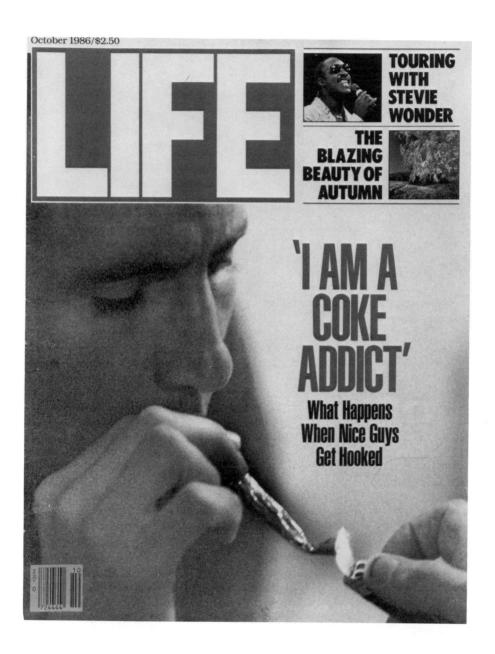

15. Many publications find it difficult to use more visceral imagery of difficult topics, probably out of fear of offending readers and advertisers. In these photographs about cocaine addiction, besides the subject's hands over his face in the last picture, circumstances seem hardly disagreeable, even though the text dramatically says otherwise. Photographs by Grey Villet, *Life*, October 1986. (Originals in color.)

A A ADDICT'S SEIF-DESTRUCTIVE TORMENT

The first time void on, tock-' a visit and only again shoot ob, tock-' a visit and only again shoot sold on, tock-' a visit and only again shoot sold on the visit and the visit of the visit and the visit of the visit and the visit of the v

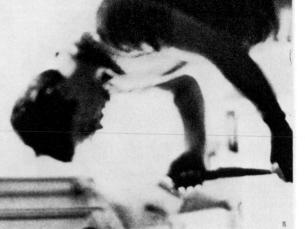

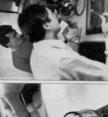

OWE ME ANOTHER \$150'

GET INTO THE SHOWER'

HE POWER THIS DRUG HAS IS AMAZING

like object.¹¹ The first spread of the photo essay shows the same man smoking, but now from the other profile, in what looks like a spacious kitchen with another young man wearing a pastel-blue shirt in the background cutting something with a knife. The second headline reads: "Hooked On Hell: An Addict's Self-destructive Torment."

Turning the pages of this essay, one sees the young man in various settings—being hugged, exercising with weights, in a car dealership where he worked. There is also a series of images about preparing the cocaine. Compared to the photographs, the accompanying headlines are much more dramatic ('''Easy! Or You'll Owe Me Another \$150,'' I Need a Few Lines to Get into the Shower'''). Then the photographs on the last spread ('''The Power This Drug Has Is Amazing''') show the man in an expensive sports car, looking out at a very nice shorefront view, and, in the final image, with his hands covering his face.

Even though the headlines and text make it obvious that the magazine's editors knew that cocaine addiction was often a "Hell" and a "Self-Destructive Torment," the pictures show the opposite—the addict enjoys a good apartment, the use of an expensive car, and an ocean view, and is hugged by an apparently warm and vivacious woman. In the pictures, all the suffering is summarized by putting one's hands in front of one's face (figure 15).

This treatment is unfortunately similar to those of serious subjects in other magazines whose editors seem afraid of depressing the reader or displeasing the advertiser. In order to be popular and sufficiently "upscale," editors will illustrate a story on a national problem that affects "nice guys" with pictures that seem to make everything come out all right. It might be different if the problem were affecting not "nice guys," who are presumably like the magazine's readership, but others further down on the economic scale or farther away in the world.

By contrast the essay published in 1965, when drug addiction was less of a national problem, was headlined "'We are animals in a world no one knows.'" The opening spread shows a couple crossing a city street. It is only turning the page that the reader sees the needles piercing their arms, and the headline "Two lives lost to heroin." Then images of their lives unfold: robbery, prostitution, nodding out, jail (figure 16). We follow the couple as if the photographer was there all the time

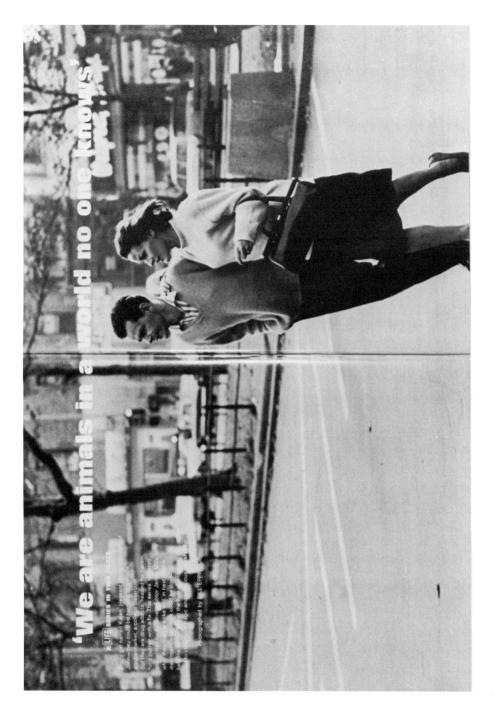

16. This *Life* essay went considerably deeper into the lives of addicts more than two decades before the "'I Am A Coke Addict'" story was published. Perhaps it was easier to show the addicts' anguish when such addiction was perceived as more distant from the magazine's readership. Photographs by Bill Eppridge, *Life*, February 26, 1965.

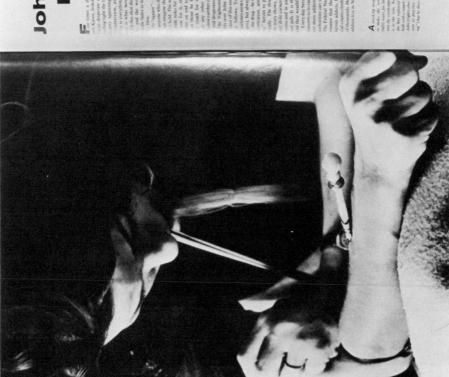

Lives Lost to Heroin John and Karen, Two

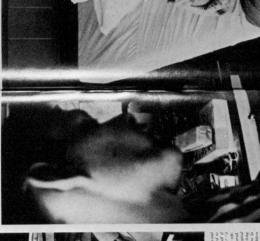

hospital: 'Stop nodding, they'll throw me out' He visits her in a

The cops search them-

You got to fight overdose: The deadly it, Billy!"

John out of jail: 'Don't play with my brains!'

living with them, for weeks. Their torment seems evident and unforced. A week after this essay appeared *Life* published another photo story, this time detailing the possibilities of being cured of similar addictions.

One cannot assert that these changes in editorial photography are all completely new, or that there are not many publications that attempt honest, informed photojournalism, including the current *Life*. But in this country it may be easier for some local newspapers, not constrained by the need to have a slick national presence, to strive to explore contemporary society photographically. The old *Life*, and other publications of its day, were certainly manipulative and condescending to their readers, but they could also transcend glibness and were less cynical and stylized than many contemporary magazines that use photography. In fact, in today's context Henry Luce's statement written before *Life*'s first publication seems almost radical. "We have got to educate people to take pictures seriously," Luce wrote, "and to respect pictures as they do not do now."

As photojournalism becomes more of a high-pitched performance for the eyes, disconnected from the intellect and the emotions, photography's translucent relationship to the world is further clouded. And with these developments in mind, electronic retouching, with its promise of control, seems less a radical departure than one might otherwise think. The photograph that discovers and uncovers the world is harder to simulate than an image that simply illustrates one's ideas about it. But in the current editorial environment, where the world's realities are often kept at a polite or voyeuristic arm's length, photographic simulations are becoming increasingly difficult to detect while, for many who control their use, increasingly to make sense.

Bringing Back Marilyn and Other Complications

THE NEW COMPUTER-BASED IMAGING TECHNOLOGY and its challenges do not stop, however, at compositing and retouching. There are other technological innovations in progress or more recently introduced that will make the photograph even more ephemeral and malleable, probably even capable of being synthesized from scratch.

In recognition of the range of possibilities, the National Press Photographers Association sponsored, in 1989, a week-long "Electronic Workshop," with the goal of "preparing photojournalists for the computers and cameras that will change photojournalism." The featured invention was the electronic still video camera, a device that allows photographic images to be made and immediately transmitted around the world via telephone lines and satellites, without ever existing as a negative or print. Electronic still video cameras record photographs on small, reusable magnetic disks, each holding up to fifty images. These cameras, already on the market for professionals and amateurs, do not require that the disks be chemically processed in a darkroom like conventional film—one can immediately look at the images on a television set. If a photographer is on deadline, the disk can be placed into a transmitter and the images sent directly to a newspaper or magazine office in minutes to appear on the editor's video monitor. This technology may, for example, allow a newspaper photographer to stay until the end of a baseball game instead of leaving halfway through, since there is no need to develop film—allowing the press to vie with television for fast-breaking news. The same process also would permit a surveillance photographer to transmit an image over the telephone to police headquarters immediately.

The still-video system is excellent when measured in terms of speed and efficiency, making it highly useful for newspapers and some magazines, and will undoubtedly gain wider acceptance as the technology improves and the image is recorded with greater resolution (right now image-quality is markedly inferior to conventional 35mm film). After the photographs are transmitted the editor can immediately select an image, then crop it, correct the color, increase contrast, or make other alterations and transmit the image directly to the printer. Since a negative or print is not necessary at any stage of the process, the photograph never has to appear on a piece of paper, as hard copy, until the image is finally printed in the newspaper or magazine.

Furthermore, because the disks are made to be used again, and each image can be individually erased and recorded over, there is no equivalent to an original, archivally permanent negative. This makes it even more difficult to prove or disprove the authenticity of the photograph. Not only is the reusable disk more alterable than a chemically processed negative, the image can also be modified on a personal computer before it is transmitted. (While any image can be digitized and altered on a computer, the physical presence of a conventional print and negative may at least serve as a deterrent to gross modification.) Also, if images are individually rerecorded there is no equivalent of a contact sheet in which one can see the thinking of the photographer develop and understand the context in which the image has been made. The image becomes, in a sense, like an out-of-context, deracinated quote.

Moreover, if an editor or production person alters the image en route to the printer, and the photographer records over the original image, then it is virtually impossible to prove how the image was changed, or even the fact that it was retouched. Or, in a more general sense, because of the non-archival nature of the disks, disputes may be difficult to resolve, hinging more on the word of the photographer against that of the publication, or against the subject of the photograph who may claim the photograph was faked. It may become harder to invoke the "right of the public to know" if it is unclear whether one is reporting or fabricating the image.

Images floating around in computer systems can also be used long after an event, when it might be even less likely that the photographer has retained the reusable disk or stored the image elsewhere. Given the large amount of storage space required for digital imagery, it is unlikely

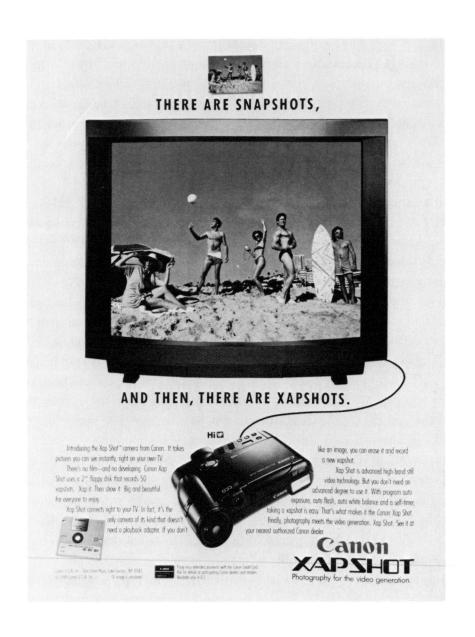

17. The still video camera, manufactured by several companies, uses an erasable disc that holds up to fifty photographs. Each image can be seen immediately on a television screen without any chemical processing, making it potentially attractive both to amateurs and news photographers on deadline. This ad appeared in *Life*, June 1989. (Original in color.)

that photographers will preserve every image; they may simply keep a small number. Furthermore, if the selected images are stored in digital form there is no original, and the possibility may exist of further altering and rerecording the image. Ironically, this is also a good way to preserve photographs, because unlike a color print or negative there will be no fading: the same print quality can be obtained forever since digital information does not deteriorate over time. In general, however, the identity of the photograph, once concrete and static, becomes considerably more like that of other diffuse data as image parts are manipulated or traded.

As high-definition television is perfected—predicted to be a billion-dollar business by the year 2000—the identity of still photography will be further transformed. It is already possible to enhance television images into acceptable still photographs for publication (one sees video images in the press from time to time, particularly from news events where photographers were either not present or deemed less effective). The conversion to still images will be considerably easier with the advent of higher resolution television having a clarity comparable to that of 35mm photography.

The day is coming when it will be unnecessary to hire still photographers for a variety of tasks. Editors will become surrogate photographers who can simply select images from a live video transmission while, in a sense, looking over a cameraperson's shoulder. Or, working more leisurely, an editor can later choose still images from videotape (unlike the photographer, who must make a selection as the event is happening). And with the recent move toward giant communications conglomerates, such as the union of Time Inc. and Warner, the photograph may more frequently be excerpted from the moving picture. Again there would be a diminishing of viewpoints available to the public.

It is not just editors who will take on the role of photographer. Robot video cameras can stand in for photographers in certain predictable or even dangerous situations. They can be positioned in courtroom or press conferences, or at the scene of a nuclear accident or at a battlefront, for example, rotating at times or programmed to follow loud noises or other stimuli. As in so many other industries, the manual worker will be re-

placed by a machine. And we can ask the question—how different is the photographer from the steelworker?

The current move to make reference libraries of photographs more accessible to computer searches (including the very extensive holdings of the Library of Congress) will allow ever greater numbers of nineteenth-and twentieth-century images (including lantern slides and glass-plate negatives) to be made immediately available. Image Bank, the world's largest commercial photographic archive with nearly fifty locations ranging from Los Angeles to Montevideo to Stockholm, already allows their clients to receive up to 50,000 images on a video disk to peruse and select from; it is likely that such libraries eventually will make photographs available over the telephone line. In light of potential computer modifications of their images, there is said to be an "informal understanding that the stock house [Image Bank] will notify the photographer if requested changes are 'drastic.' "1

The establishment of such computer links of photographs and the ease and variety of ways in which imagery can now be transformed make it very difficult to establish and protect authorship. There is also always the possibility of the unauthorized digitization of images from publications and television. A photograph of the Himalayas, for example, can be modified in so many different ways—changing colors, adding a few hang gliders, putting in a sunset—that it will be difficult to know or prove whose image it was originally. (The postmodern instinct for appropriation may become so widely acted upon that it will make the "original" newly valuable.) It will also be harder to protect the first image-maker's copyright and to make sure that they are paid some heretofore undetermined percentage for future uses (the first, or base, image may increasingly have no resale value). One can imagine highly efficient computerized photographic agencies typically "touching up" images before the client ever sees them.

The photographer may become, like a Third World country, counted on only as the supplier of raw materials—the photographs—to be somehow "refined" by those who control their publication. Processing of film, no longer necessary, may be replaced by image manipulation as a critical step in making a photograph, and the creator's decision-making will occur later in the "photographic" process.

And while the media photographer's power declines, that of the editor or art director grows, with increased choices and a centralized command to survey and make decisions about all the imagery available for selection and alteration. The "eyewitness," in turn, becomes increasingly remote and secondhand.

Also, amateurs will soon have access to technology that allows the still-video image to be digitized, appear on a home computer and be immediately manipulated, or to be taken from a live television broadcast and altered. Their relationship to the photograph, including their belief in its veracity, is sure to change. It is a far cry from the early days of amateur photography when one would send a camera to Eastman Kodak with the exposed film inside to be developed and printed and then passively wait for the camera to be returned with new film loaded inside. In the near future even parlor games will probably involve modification of photographs—and then we'll see how Aunt Edna would look a foot taller and with green hair.

The ephemeral photographic snapshot made by the still-video Xapshot or other amateur models, made to be viewed on a television screen, will be less trustworthy as a document of one's own family history. Just as we have nearly lost the written letter as an intimate, reliable document to find out where we come from, we may be depreciating the photograph as well. If we know how easy it is to place our son retroactively in the front of the class in the graduation picture, or give his father more hair, or send a picture of his fiancée to the family in which her tight sweater has been exchanged for a more conservative blouse, the role of the photograph as conservator of our past will be considerably less meaningful.

But there is a new camera being developed at the MIT Media Lab that makes even this discussion seem innocently nostalgic. Called a "range camera," it is a camera with two apertures and two focuses that records the varying distances of objects from itself, allowing this three-dimensional information to be transferred as data into a computer. This then allows the viewer to look at a scene from a variety of angles, using a joystick to control perspective (one can resee a scene from a perspective the photographer may never have looked at). One can also change the image's lighting, coloring, or even its depth of field, and add or

Figure w: Original Image

Figure x: "Rangepic"

18. The "range camera" being developed at MIT's Media Lab collects visual data, which allows the image to be "re-seen" from other angles and the lighting and even the focus to be changed. Objects and people can also be added to or subtracted from the image database.

A laser scanner is one way of measuring the distance of objects from the camera (lighter areas

Figure y: Original Image from New Perspective

Figure z: Original Image with Shorter Depth of Field

are closer) [figure x] in order to reconstitute them [figure y]. The original image can also be ''re-shot'' with a different depth of field [figure z]. V. Michael Bove, Jr., Media Laboratory, Massachusetts Institute of Technology.

subtract people or other elements—the photograph becomes living sculpture (figure 18).

All of these permutations of the photograph are consistent with its increasing malleability and will undoubtedly transform its acceptance and identity. But they all use extant imagery. There is another approach as well, even more revolutionary, which allows the image to be created from scratch.

Robert Capa, perhaps the premier photographer of war in photojournalism's short history, admired for his courage and humanity, once asserted, "If your pictures aren't good enough, you aren't close enough." This statement articulates as well as any other both the photographer's traditional and practical requirement of proximity to the subject, and also photojournalism's vaunted tendency toward empathy. However, it soon may be as realistic, if less romantic, to assert, "If your pictures aren't good enough, you aren't mathematical enough."

There is a new kind of computer imaging that does not require nearness to one's subject, or even the use of a camera. Instead, it utilizes mathematics to generate imagery that is photographically realistic. It is a technique first developed for use in flight simulators, which have since become an effective and economical mainstay in the training of pilots. Without leaving the ground, but by simply turning his or her head from side to side in a cockpit, the pilot sees computer-generated images programmed to simulate the experience of flying at different speeds and altitudes, and in different weather conditions and times of day. The images, which would be impossible to store photographically because of the enormous number required, are generated for each situation. They are realistic enough for the pilot to gain crucial experience in landing a plane, steering it through simulated storms—he or she can even become airsick.

Computer image-generation is a rapidly growing field, employed by engineers, architects, doctors, and many other professionals. It can be used to simulate a building not yet constructed, for example, and then program a high wind to see what its effect would be on the structure. One can also rotate the building to see what it would look like from different directions, or in different seasons and locations, or at different

times of day. It can even be programmed so that one can "walk" through it, as in a Department of Defense trial in which soldiers could wander street by street through Aspen, Colorado without ever having to go there.

Doctors can use this technique to realistically plot out a surgical procedure before cutting the patient. One such application of computer imaging, recently described in *Life* magazine, allowed doctors to plot "down to the last millimeter" the extensive operation required to reshape a badly deformed baby's skull. It also made the operation one hour shorter. Textile designers can see immediately how a quilt would look with three-percent smaller squares, and NASA engineers can judge how comfortable an astronaut would be while designing different-sized chambers.

To generate such imagery, information is entered into the computer that describes the object to be depicted, including its dimensions, color and texture, and programs are devised to construct the image on the screen as accurately as possible, taking into account perspective and lighting. It is a difficult procedure, because of both the enormous number of pixels that have to be signaled and the great variety of possible hues for each, and because it is often difficult to use mathematics to describe visually complex forms (while it is easy to mathematically describe a circle, it is quite another thing to describe a head of hair). Joseph Deken, in his book *Computer Images: State of the Art*, suggests that if one judges by the number of calculations, rather than saying a "picture is worth a thousand words," it is more accurate now to say that a picture is "worth a million words."

So far, the greatest success in image-generation has been in simulating the non-natural world—cans, rocket ships, tables—and, not surprisingly, worlds less familiar to us, like outer space. Conversely, natural forms, particularly the human face, have been most difficult to simulate, because of both their visual complexity and, in the case of the human face, our extraordinary sensitivity to its nuances. Recently, however, the serendipitous founding of a new branch of mathematics, "fractal geometry," which can describe the repetition of complex forms in nature, has been found useful to create images of increasing complexity and irregularity such as the side of a mountain or the leaves of a tree.

In movie-making props can be simulated on the computer without having to be built, and this technique has been utilized in such motion pictures as *The Last Starfighter*, several *Star Trek* movies, and *Young Sherlock Holmes*, simulating such things as rocket ships, a planetary explosion, and a stained-glass man who comes to life. Once programmed, it is possible to make the props do virtually anything, since natural laws such as gravity do not apply to computer simulation. Moreover, a much smaller number of people is required to work on the movie, since carpenters and the camera and lighting crews, among others, become expendable (although initially many programmers may be required).

Some filmmakers hope that eventually one will be able to simulate human beings realistically enough to bring back long-dead movie stars to act in new movies, copyright laws permitting. It might be possible, for example, to simulate Marilyn Monroe and Charlie Chaplin acting in a new romantic comedy, or John Wayne with a younger Ronald Reagan interacting with the film's viewer. One begins, to an ever greater extent, to live in what has been called "virtual reality."

The implications for journalism, however, are more immediately problematic. In a recent book, The Media Lab, author Stewart Brand suggests that we just go ahead and simulate on a television news program the President declaring war, and make the possibilities for visual fakery and disinformation, what he called "toxic information," obvious to the public. 4 In fact, there is a 1981 novel, The Myrmidon Project, written by television news anchorman Chuck Scarborough and writer William Murray, which describes the murder of a difficult but popular broadcaster, Harvey Grunwald, and his replacement, virtually undetected, by a programmed simulation. "Once we had digitalized Harvey's image and analyzed him in all his moods, expressions and what not," explained a key character in the conspiracy, "it became relatively simple to *create* a moving, breathing, speaking Harvey without having to have his actual physical presence in front of a camera. And we could improve him." Similarly, the 1985 film, Max Headroom, bills itself as introducing "the world's first computer-generated TV host."

But some working with the computer, like Alvy Ray Smith of Pixar, feel that "Reality is merely a convenient measure of complexity." It is a useful yardstick, a measure of the advances in technology. What inter-

19. *Tin Toy*, the first computer-generated movie to win an Oscar, is about a baby as seen from the point of view of a toy. While not yet photographically realistic, the movie includes a variety of technical advances, including the programming of more than forty facial muscles for better human simulation. A 1988 Pixar film, directed by John Lasseter, technical direction by William Reeves and Ellen Ostby. (Original in color.)

ests him, and others, is "to find out how far you can go away from reality and still have people follow you."

In getting there, Smith's Pixar colleagues John Lasseter, who came from the Disney Studio, William Reeves, and Ellen Ostby led a team that in 1988 created the Oscar-winning film *Tin Toy*, featuring a computer-generated baby which can simulate the action of forty muscles and engage in a rather lifelike sneeze (it is the first computer-generated film to win an Oscar; figure 19). According to Smith, many viewers find the baby "monstrous" because it is close enough to a human being that its differences make it seem somewhat perverse. Although the film's sophisticated images are said to have taken some twelve trillion calculations each to execute, it is predicted that even as soon as five to eight years from now those images will be producible on a personal computer. 6

Dozo, a computer-generated "sexy cyborg" with slicked-back short black hair who dances and sings, "voic(ing) the concerns of the computer-generated in this less-than-perfect world" ("You have the power to make me feel, Your microchips can make it real, Electric feelings burn so much; A simulated sense of touch"), was introduced this past summer in a three-minute music video by Jeff Kleiser and Diana Walczak. Created from "a shapely body database" (actually through an image bank of sculpted figures that are melded together to create motion and by using the recorded gestures of a dancer as a base for the character's movements), Dozo was designed to have enough human characteristics to make the audience feel empathetic, says Kleiser, without being an exact replica of a person (figure 20). Kleiser sees a "God complex" in the mindset of those obsessively attempting to simulate human beings.

A trend may be emerging to create a whole new cast of partially realistic humanoid characters (it may also be a way of attempting to get around copyright problems that arise when one tries to simulate the famous), or to combine characters from a variety of arenas, as was done in the Disney film *Who Framed Roger Rabbit?*, which mixed cartoon characters with human actors. Yet even with breakthroughs in artificial intelligence, the Marilyn Monroe clone, at least for the foreseeable future, may remain an elusive novelty, never able to attain the specialized internal dynamic of the original person. Of all the tasks that computers

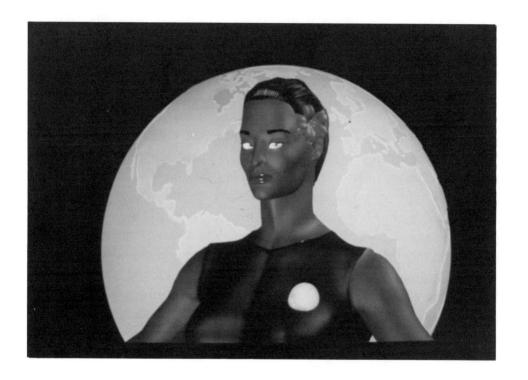

20. "Dozo," a computer-generated "sexy cyborg," sings and dances in a 1989 music video by Jeff Kleiser and Diana Walczak. (Original in color.)

can perform well, simulating human charisma is not at the top of the list.

In still photography simulation of humans is simpler, in part because there is no requirement to have an animated, walking and talking person. (Movies, which need twenty-four frames per second to create the illusion of movement, also require vastly more computational power than do still images.) In stills, static visual mimicry is all that is necessary. Already at this point, if one is willing to limit the simulation to an artificial scene, Alvy Ray Smith suggests one should be able to attain photographic realism in a still image, with human simulation not far off.

It is simpler, however, with all of the still imagery available, to composite or otherwise alter preexisting photographs to attain the image one wants. Prototype programming techniques are lengthy and difficult processes to establish. For example, one of the greatest successes in photographic simulation, which required one hundred hours of calculations and several months of work by scientists, appeared on the cover of the magazine *Science 84* under a large headline, "This Picture is a Fake." At first glance the cover image was surprisingly and effectively unexceptional—it appeared to be a photograph of a hand holding a pool cue near five pool balls on a dirty green felt table, with four of the balls blurred and moving in different directions. The balls cast shadows on the table, and a few reflect what appear to be lights and windows (figure 21).

But in its fakery this cover was ahead of its time, representing three separate imaging techniques, only one of them conventionally photographic: the hand and pool cue were photographed in a studio. Then, using a second technique, this photograph was composited onto the image of pool balls in motion. To do this, a computer was used to clone or "reverse crop" the green felt downward to provide a place for the hand and cue stick (the felt was also extended upward to provide a background for the logo of the magazine).

However, the felt never existed, nor did the pool balls. They had been generated mathematically using a third imaging technique. Created by researchers at Lucasfilm in California, the major triumph in this image was the development of a program that simulates the blurred look of objects in motion. Although this image, which would have taken only

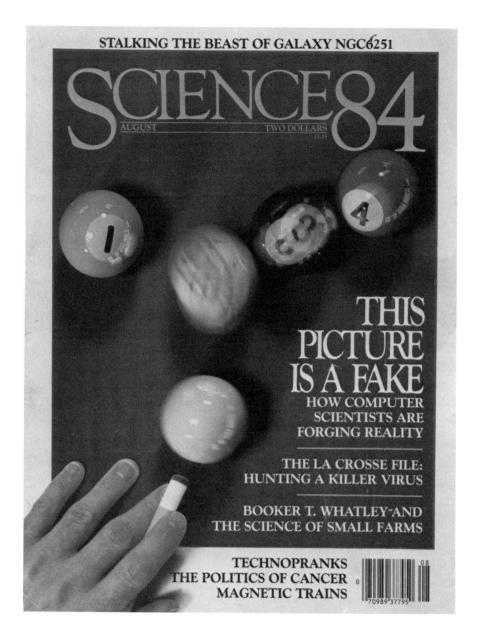

21. This cover image represents three ways of making photographic imagery: a conventional photograph (hand and billiard cue), a computer composite (hand and cue combined with billiard balls), and a mathematical, computer-generated image (the billiard balls in motion), the latter created by researchers at Lucasfilm. The common electronic technique of "cloning" or "reverse-cropping" was also applied (the green felt has been extended upward to allow space for the magazine's name). *Science 84*, August 1984.

about a second for a camera to record, required an extremely lengthy and difficult series of calculations, it was created by a prototype technique which can then be applied to other images.

In the computer-generated world of the imagination, images often look photographic, but bizarrely so—gravity no longer matters (since the image created is not of anything that actually exists physically), apparent lighting sources are confusing and unnatural, colors are often eerie, objects seem to come in strangely-shaped sizes, and the image often appears to be too clean. One also sometimes sees a mathematical imprint in the imagery, as if the branch of mathematics being used in image generation becomes the new natural order. Such simulations, if successful, seem to question the nature of existence. For example, what does it mean that the appearance of the world can be simulated mathematically? Is mathematics less abstract than we may have thought? What logic or interrelationships in the world does this mean we have overlooked? Or what of other "worlds" that can be computer-generated and are internally consistent but do not resemble ours? Is there an alchemy, a science, or something else at work?

For artists as well, the potentials of computer-based technology are enormous. In a digital environment, sound, text, moving and still images can be easily combined with other information sources. Manual skills, such as the draftsman's or the dancer's, become less important, while possible conceptual linkages are vast. Yet we are still only in the early stages of the exploration of such possibilities. As David Em, an artist using the computer, put it in 1984: "As you have kids that are growing up with video games and growing up computer literate, fifteen years from now the true Michelangelos and Leonardos of the medium will come about to blow us all away. And we just have to realize that these are the Paleolithic days of the computer medium."

Reading Photographs

HOW THEN, after all that is happening in computer imaging, can one safeguard the integrity of the photograph in its populist role as societal informant? The immediate and sufficient reason for posing the question is to prevent the public from rejecting all photographs as unreliable, thus excluding photography from the public debate. But there is a paradox: photography is already as unreliable as any other medium, even without the addition of electronic technology.

As a society we have come to the historic moment at which it is increasingly urgent to reject the myth of the photograph's automatic efficacy and reliability, particularly when the myth is soon to be punctured. In order to contemplate its future role in society and the impact of new technologies, it is necessary to at least acknowledge that photography is highly interpretive, ambiguous, culturally specific, and heavily dependent upon contextualization by text and layout. It may be helpful, partially as a response to the use and abuse of electronic imaging techniques, to begin to divide photographs, particularly those published in a journalistic context, into categories of fiction or nonfiction, as we do with words, or to label images as to their source and approach, such as "computer-generated" or "photo-illustration." Just as a newspaper attempts to distinguish among editorials, critical reviews, feature and news articles, we can begin to differentiate photographs by genre.

This becomes a somewhat novel recognition of the complexity of a supposedly simplistic and unbiased medium. For example, what would photographic fiction be if "the camera never lies"? Is only a photograph that has been subjected to physical modification after the fact fictitious? Or, to take the contrasting view, are all photographs fictions by virtue of being decontextualized representations of moments that do not actually exist independently? What then is nonfiction photography?

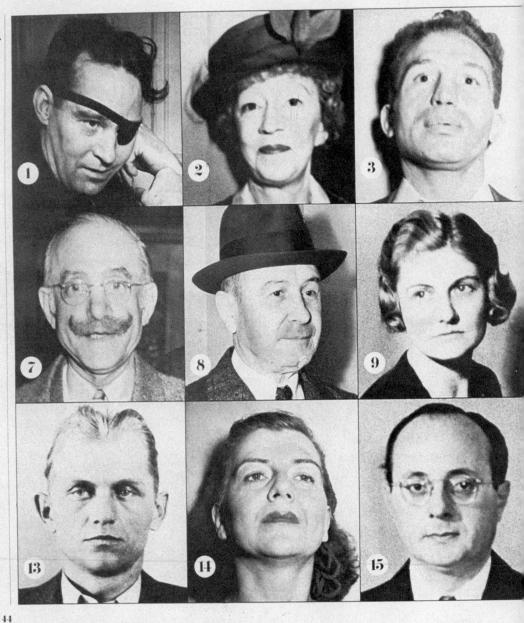

22. In 1947 *Life*'s editors attempted to disprove there was such a thing as a "criminal look" by asking its readers to determine which among 28 faces belonged to a criminal and which to a mystery writer. It was at least as much a demonstration of the interpretive capabilities of photography. In 1976 Time-Life Books reproduced (above) an abridged version.

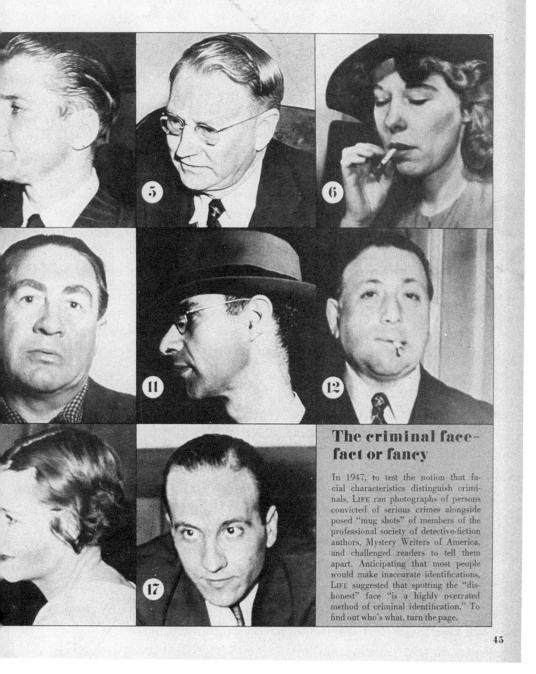

Answers to Writers/Criminals Test Writers I and 6 were married, 10 specialized in crimes Writers: I, 2, 3, 6, 10, 11, 12, 14, 15. Writers I and 6 were married, 10 specialized in crimes that took place in Latin America, and 15 was half of the Ellery Queen writing tream. Criminals: 4, 5, 7, 8, 9, 13, 16, 17. Number 4 killed his wife, number 5 his wives, 8 was identified as an 'Al Capone henchman,' and 16, Kathryn Kelly, teamed up with husband ''Machine Gun'' Kelly for a kidnapping for which both were sentenced to life in jail.

The answers range much further than a consideration of electronic retouching techniques. One might begin a consideration of photography by broadly asserting that a nonfiction image is one that is responsible to the facts of a situation. It might further be said that a significant journalistic or documentary image must adhere to the facts while also attempting, as best it can, to get at a situation's essence. Otherwise, respecting only the facts can be extraordinarily misleading, and makes an exclusive reliance on photography's vaunted descriptive function, its cornucopia of details, misplaced. Concentrating solely upon the physical alteration of the image, without being able to first read the photograph, to understand what it says, may be missing the main event.

For example, over forty years ago *Life* quizzed its readers, asking them to consider a gallery of faces and decide, on the basis of the images, which half of the twenty-eight people depicted were criminals and which mystery writers. The avowed intent here was to disprove, as had been theorized as early as the nineteenth century, that there was such a thing as a criminal face.¹

It was a seductive test, quasi-scientific in its appearance. The facts were there for the reader's examination. Each person's head and shoulders were photographed by the camera and presented one after the other like "identity" cards. Ostensibly, one could have applied a lifetime of experience to the decision. But while such a biological-criminal relationship had already been generally rejected, the photographs were rather cleverly selected to make sure that the reader would agree that distinguishing the "criminal look" is "a highly overrated method of criminal identification."

Persons number 3, 10, and 14, for example, share certain physical characteristics: their jaws are enlarged and foreheads prominent, the insides of their nostrils evident, while their eyes remain recessed and unfocused (see figure 22 for an abridged version of the *Life* gallery). If a reader chose any of them as criminals, he or she could believe it was because of these characteristics when the more important factor was the manner in which they were depicted. Each of these "criminal" types had been photographed disrespectfully, in the same abrupt manner one might have photographed a suspected criminal in a police station. Each of these people was shown from below, with his or her head thrown

back against a plain light wall on which a direct flash left a harsh shadow outlined against the side of their faces. The viewer had to look up and into their nostrils, from a photographic perspective that exaggerated their other features.

Each of the three "criminals" of course was a mystery writer. Person number 17, on the other hand, was photographed from slightly above with a gentler light that seemed to give him a dreamy, faraway look in his eyes, as if he were sitting in a chair in a study with what appears to be wood paneling behind him. It turned out that he was "John Fiorenza, a Manhattan upholsterer [who] raped and strangled writer Nancy Titterton in 1936. He was electrocuted nine months later." The choice of clothing and other accessories is also at times misleading: a woman with a cigarette and a man with an eyepatch (this is 1947) were writers, as was a man photographed in profile wearing a hat indoors, while the suits and ties mostly belonged to the criminals.

While the photographs presumably resembled each person, most were essentially false. The magazine's editors were playing to the reader's tendency to accept the photograph without evaluating the way in which it has been constructed. It is clear that with a photograph, even one true to the facts, one can make virtually anyone appear to be good (such as Hitler photographed playing with his dog) or evil.

It is the angle of the lens, the quality of lighting used, and the piece of backdrop employed that lead to conclusions about these people's characters. *Life*, purportedly challenging stereotypes, primarily managed to show the magazine's talent in directing the reader. (*Life*'s editors did explain in a long caption that the writers had been photographed "against bare walls, in bleak surroundings and without special props" like criminals are "usually caught by the camera." This was, however, only sometimes true.) To put it more broadly, Fidel Castro suggested that one can characterize Havana in different ways by choosing either to photograph its buildings with peeling paint or its excellent health care facilities. Or, an article in *Washingtonian* magazine reported how, using the conventional technique of cropping, the *Washington Star* newspaper was able to use a single photograph to show Senator Edward Kennedy, for whom womanizing has long been a sensitive issue, exiting a Kennedy Center gala in three different ways. In the first edition he was de-

INFORMATION PLEASE

Q: I was surprised to read recently that Secret Service agents are present when President Carter's son Jeff and his wife Annette "smoke dope" while visiting the north Arlington home of a woman who works in the White House. This gives me an idea for a thriller novel. Would the Secret Service discreedy look away even if a President committed murder?

A: A Secret Service spokesman said your question "is in such poor taste that I don't even care to comment." But an agent said unofficially, "We're not moral eunuchs. Soft drugs and sexual shenanigans are one thing, but it's hard to conceive of anyone in the service keeping quiet about a major crime, especially since Watergate."

Q: While in California recently I heard about a new movie, The Senator, Starring Alan Alda, which supposedly exposes the philandering of a real-life solon, one now out of office. Just how closely does this movie track recent reality.

A: Not at all, reports director Jerry Schatzberg. The senator, played by Alda, begins as a hard-working, conscientious lawmaker, but is trapped by a de-

teriorating home life. He falls in love with a lady labor lawyer, played by Meryl Streep, and his wife commits suicide. Although "a few anecdotes' might connect up with real life (Alda researched his script in Washington). Schatzberg insists the movie "is more about marriage than about any real people in public life."

Q: I notice the top player at my tennis club is forever sipping Gatorade between games. Does it really help?

A: Yes. If you exercise during Washington summers you should replace the body fluids you lose from perspiration. If you get too dehydrated during a tennis match or other sport, it can affect your performance. You now can buy powdered Gatorade at most supermarkets. Where a quart bot tle of Gatorade costs around 69 cents, you can buy enough pow-der for \$2.99 to make eight quarts if you follow directions. Actually, we suggest you use only half the recommended amount of powdered Gatorade in a quart of water, thus making sixteen quarts from one can of powder. It tastes just as good, has fewer calories. costs less than 20 cents a quart, and you can add the juice from a lime or lemon to make it taste even better

Q: In a recent interview in Ladies' Home Journal, Joan Kennedy tells her biographer, Lester David, that she "really doesn't know" whether she is still in love with husband Edward. Yet later she states that while the thought of being First Lady does not "enthrall" her, she'll probably be at his side if he runs—and if she feels she has conquered her alcoholism. Why does she insist in conducting her martial therapy in public?

A: A maximum of two people understand the intricacies of any given marriage. From a pragmatic point of view, however, Joan's

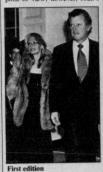

willingness to give such interviews keeps the Senator on notice that he too has to control his behavior. If he does, she 'll campaign for him; if not—well, Ted, you explain why lleft. The visible evidence is that Ted has cut down out who-es

on his womanizing, or at least is more discreet. He is sensitive on

the issue. The first edition of the March 27 Star had a picture of

him leaving the Egyptian-Israeli KenCen gala with a gorgeous young thing at his side. The second edition cropped the woman out of the photo. By the third edition, the Star finally straightened out who-escorted-whom: Kennedy now walked with Monsignor Francis J. Lally, of the US Catholic Conference, an old

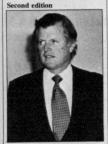

Final edition

CAPITAL COMMENT

THE WASHINGTONIAN 15

23. In three editions of one day's *Washington Star*, Senator Edward Kennedy was first shown exiting an Egyptian-Israeli Kennedy Center gala with a young woman, then by himself, and finally with a monsignor who was an old family friend, all using the same photograph and the conventional technique of cropping. This was pointed out in *Washingtonian* magazine, June 1979.

picted escorting an attractive young woman on his right, in the second edition the woman was excluded and he was shown by himself, while in the third edition, finally clarifying the situation, the *Star* presented Kennedy with a monsignor of the Catholic Church, an old friend, who had been on his left (figure 23).²

The paradox of the photograph, however, is considerable larger. The photograph is not only selective and potentially distorting, but despite its apparent precision often highly ambiguous. For example, the photograph of a dog on a treadmill could be a lead picture for a story on a health resort for dogs; the second image could be used to illustrate a story on dog dentistry (figure 24). But as one looks at these same photographs in the sequence of the other images and text in the magazine essay ("The Savage Pit") in which they were published, one realizes how violent is their meaning. The photographic essay, like a film, has its own special syntax.³

But perhaps the best example of the ambiguity of a single image concerns what may still be the most famous war photograph of all time. Robert Capa's 1936 image, "Falling Soldier," a man said to have been photographed at the moment of his death, might not have been that at all (figure 25). As pointed out by Phillip Knightley in his 1975 book *The First Casualty*, what would the value of the image have been, despite its photographic realism, if captioned "A militiaman slips and falls while training for action"? Some critics speculate that Capa's photograph may have been just that, or posed, and not a man depicted at the moment of his death. But there is no way to know just by looking at the image, and when captioned in *Life* magazine the following year "The instant he is dropped by a bullet through the head," the photograph took on the enormous symbolic value of the valiant but futile struggle against fascism rather than what might have been only the story of a man slipping.

Although there is no proof that the photograph was or was not what the caption said it was, and Capa has a much admired reputation as a photojournalist, the question of its literal accuracy is not, as Capa's biographer Richard Whelan would have one believe, "morbid and trivializing." Whelan argues that "the picture's greatness ultimately lies in its

symbolic implications, not in its literal accuracy as a report on the death of a particular man."

If this argument were to be accepted, then one might stage an image to support any cause one favored. For example, why not set up a photograph of a Chinese man committing suicide in front of the United Nations over the treatment of his fellow Chinese? Symbolically it would have great weight, the man would not have to die, and why is its literal accuracy of any more importance than that of Capa's in Spain? Or, as a word journalist, why not put words into someone's mouth that have great symbolic value but he might not have said. The retraction of the 1981 Pulitzer Prize in feature writing that had been given to Janet Cooke of *The Washington Post* for her portrait of a young drug addict did not deny the symbolic value of her portrait, but challenged its literal accuracy as an unacknowledged composite portrait.

Whelan misses a critical component of journalism—that one must stick to the facts even while making major statements which may transcend them. Certainly one can adhere to the facts and still miss the essence of a situation, as in the somewhat disingenuous *Life* magazine quiz on the difference between a detective writer and a criminal. But if one disdains the factual route while pretending to have taken it, the basis not only of journalism but of all documentary photography is compromised. One also thinks of the subversive message of the 1983 movie *Under Fire*, in which a blond American photographer played by Nick Nolte is asked to take a picture of a dead Nicaraguan guerilla leader making him appear to be alive so as to keep the revolution in that country alive.

These are some of the issues that those who use electronic retouching, like Whelan's argument, overlook. These issues have always been pertinent to photographic representation; now they have become more urgent and omnipresent with new imaging systems. Imagine a "Falling Soldier" retouched so that blood appears to gush from his head, removing unwanted ambiguity. Undoubtedly many would say, why not?

However, once the idea that the photograph is only a transcription from reality is discarded, a new appreciation can emerge. One begins to understand that photography's various methods of representation are not

24. Taken out of context, photographs can be made to have a variety of meanings that their authors never intended. These two photographs could be used individually to illustrate an article about sending your dog to a health spa, or one about dog dentistry. In fact, they are from an essay about training fighting dogs (see following pages). Photographs by William Strode from "The Savage Pit," Geo magazine, November 1979.

Photographic syntax, including the interplay of visual rhythms, is often overlooked. This essay is a particularly strong example of how photographs are used to build on one another in the telling of an important and multi-layered story. The "opener" creates a mood and sense of place, which informs all of the photographs that follow it; the photograph on the third spread would

become sensationalized if it began the essay (or was used by itself); the quieter, anonymous final image places the responsibility for the dogs' savagery on their human handlers. Photographs by William Strode, "The Savage Pit," Geo magazine, November 1979. (Originals in color.)

dogs! Then you're part of your dog, you're alive. "That's the moment you have to prove yourself when the referee calls, 'Release your

fields in the eventuage of superhers of the would be for each of the eventuage of superher competition was reduced in the free would be for each of the first of

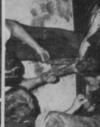

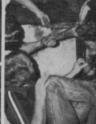

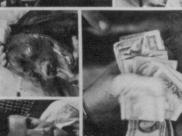

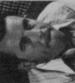

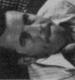

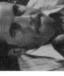

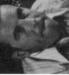

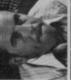

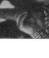

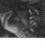

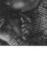

"When I'm in the pit and one of my dogs goes across and attacks the other bastard, then I feel like I was goin' across myself."

regularly six them on the dops of only other fighters in secret arctus—for a. They prize that sometimes runs as little as beyon \$100 and sometimes as much as. Du \$10,000, Often it takes two hours for Hank.

You don't sit next to your dog, you sit apposite him. You can see him, he can see you. That owes him tremendous self-confidence.

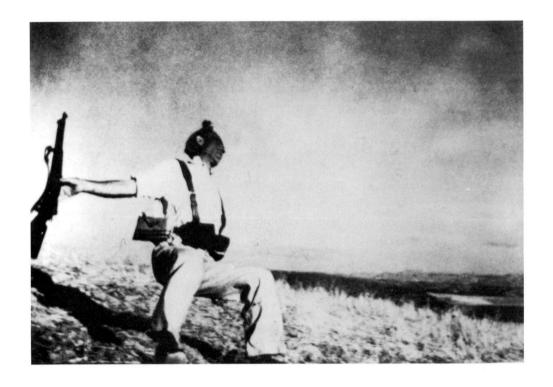

25. Falling Soldier, 1936, is perhaps the most famous photograph of war ever made. It has also been used to highlight the ambiguity of photographic meaning. A photograph's plenitude of realistic details can be manipulated according to a variety of contextualizing factors, such as caption and layout, which may be outside the photographer's control. Photograph by Robert Capa.

merely complex, varying from one genre to another, but remain linked to the culture from which the photograph is made. An argument can be advanced for photography as a rich, multi-leveled linguistic approach, articulated differently according to the codes of each culture.

A good example was related by Mexican photographer Pedro Meyer in response to a question I posed to him about the possibility of an objective image. "Would not a photograph of a pencil on a table always be just that," I asked, "a photograph of a pencil on a table?" His reply:

"It brings to my mind the story of what occurred in Peru, during an experiment to teach Spanish to the Indian population that did not speak it. The first conclusion that they came to was that someone who is 'illiterate' is only so to those who do not communicate in that specific language, but that there are many 'languages' in which someone can communicate. So it wasn't that someone who was illiterate in Spanish did not communicate aptly in some other code. This brought the team who worked on this to the idea to use cameras to discover the codes being used by these people. They would ask a question and then elicit from the children (in this particular example) a response with a picture made with very simple cameras.

"They wanted to know what these children thought of 'exploitation' and what they associated with this term. Under normal circumstances the children would have followed the lines of certain clichés, such as the depiction of Uncle Sam, but in this case they came back with some stunning images. . . . One child came back with a picture of a nail on the wall. It was only that, a simple nail on a naked wall. At first the instructors thought that the child had misunderstood the idea of the experiment. But upon further investigation they found out that these children were living in an extremely poor town, several miles outside of Lima, and in order to make a little bit of money they walked every day all those many miles into town to shine shoes. And so that they did not have to carry back and forth the heavy load of the shoe-boxes they rented a nail on the wall at someone's place in town. And the man that

rented the nail charged them for this half of what they earned for the whole day.

"As you can see, sometimes a picture of a nail on the wall means much more than just a nail on the wall. Or for a Cuban child a picture of a pencil on the table might have implications dealing with the blockade, as they had no pencils for a long time. . . . A picture has many more implications than we are accustomed to admitting. It is not a universal language, since the codes used in a picture can be deciphered in as many ways as the various cultural backgrounds of the observer. As no one can control the circulation of an image, you have no way of being sure that its contents will always warrant the same response. I therefore do not believe that it is too inadequate to consider as I did that a picture is never 'objective.'

Looked at in this way, photography becomes more variegated, less an automatic validation of the way things are. It is, like other communication systems, a way of asserting one's own feelings through the prism of one's own culture. This is a reason why computerized image banks, which allow easy access to huge quantities of photographs from all over, may distort the nature of the imagery, treating them as if photography were a kind of universal Esperanto.

For me, my initial awareness of the difficulty of understanding photography from other cultures came when confronted by thousands of images taken by Latin American photographers in a 1984 exhibition in Havana. I found myself an outsider scratching at surfaces to find wisps of meaning. Despite being photographs that are exposed in fractions of seconds, as they are made everywhere, the images often seemed to reverberate with a very different sense of time, a kind of plastic sense of the moment that appeared to linger on its way to one of many possible eternities. People who were real sometimes seemed to have been depicted as if imaginary, but in the new fantasy became more real, less temporal.

While impossible to generalize completely, my sense was that this multifaceted work, reflecting a diversity of national identities as well as individual perspectives, is in essential ways different from the more

graphically complex, technically polished, and self-referential imagery United States culture produces. For the most part the Latin American work I saw seems more appreciative of others' lives than a great deal of the work by our documentary photographers who frequently depict their subjects being deprived, with the implicit hope that they will be elevated within the ranks of our substantially more materialistic society. Furthermore, unlike indigenous photographers, foreigners in Latin America tend to take faster-paced and glossier pictures, and to implicitly compare the lives of people in the region to those in more developed countries.

As with the "nail on the wall" image made by the Peruvian child, it was not always possible to understand what the Latin American photographs were intended to mean. For example, while reviewing an exhibition of Cuban photography, I was impressed by a photograph of a young girl formally dressed in a long ruffled gown for her "sweet fifteen." Standing outdoors by the water and surrounded by ordinary-looking adults and children in shorts, she appeared newly conscious of her role as a young woman and elevated from the crowd of people around her. I viewed the image as sweetly romantic, a celebration of awakening individuality and sexuality. But the Cuban author of the photograph, Marucha, was dismayed by my reaction and pointed out that the photograph is from a series critical of the ritual, a tradition that predates the Cuban revolution and which she considers to be costly and meaningless. Reacting to the image through my own cultural associations, seeing an individual gowned as if in a Hollywood fantasy rising above a workingclass society as celebratory, I misread its intent in a socialist country (figure 26).

Also, Latin American photography has to be considered in light of the shortage and high cost of materials. Since it is almost impossible to make a fine print because of these problems, it is more difficult to accord photographs the status of prized objects, made to be looked at; their images seem made to be looked through. In certain parts of Brazil, for example, photographers have been said to be able to afford only a sheet or two of printing paper at a time. In Cuba, a wedding photographer may use one roll of film to photograph several weddings. I saw a professional photographer in Havana carefully pose a young woman in

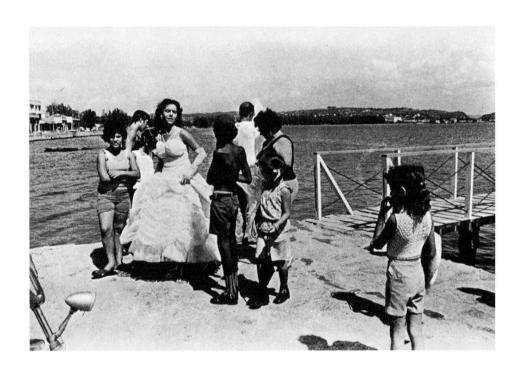

26. Cultural background affects one's interpretation of photography. Coming from a capitalist country, I interpreted this photograph to be a celebration of a young woman transcending her origins, as if in a Hollywood fantasy; the photographer, from a socialist country, intended the image as a criticism of the young woman's aberrance in adhering to an outdated bourgeois ritual. *Quinceañera* ("sweet fifteen"), Matanzas, Cuba, 1980, photograph by Maria Eugenia Haya (Marucha).

front of a white piano in a restaurant, and then make only a single exposure with his 35mm camera rather than attempting several frames in a search for the best expression.

This difficulty in obtaining material has broader implications. Few Latin American photographers could afford, for example, the quantity of film necessary to make the number of exposures required by the perpetual search for the "decisive moment"—a major genre of European and United States photography defined by French photographer Cartier-Bresson as "at one and the same time the recognition of a fact in a fraction of a second and the rigorous arrangement of the forms visually perceived which give to that fact expression and significance." So ingrained is the notion of shortage that recently several Mexican photographers on a one-day assignment for a large New York publication had difficulty in coming up with more than two rolls of film each, even though the magazine would have paid for (and undoubtedly expected) much more; by contrast, several photographers from the United States used close to one hundred rolls of film each on a 24-hour assignment for *A Day in the Life of America*.

But there are more important cultural and political reasons why Latin American photography lacks the choreographed rigor and sense of chessboard elegance that one often sees in Cartier-Bresson's work. Latin American imagery appears not to celebrate the fraction of a second, nor to find the stopping of external motion, the expression of tension and stasis in the decisive moment, to be particularly productive. Perhaps only a nervous, full-speed-ahead industrial society, accustomed to a plethora of change and enamored of material progress, would be so fascinated by fleeting instants and accord them any kind of revelatory powers. It may be that we in the North, from a stance of affluence and presumed longevity, accustomed to overlooking the eternal, to wresting control over our environment, to admiring technological prowess, to finding in the instant pleasures and satisfactions, even discoveries of a sort, can more easily acclaim the discrete fragment of time. By contrast, in Latin America there is at times a feeling of a melding of moments, days, even years from which an instant cannot be separated. There is what has been called a "magical realism."

Cartier-Bresson's sense of a decisive moment can be compared with

another sense of the moment, posited by Gabriel García Márquez, the Colombian writer, near the end of his book *Qne Hundred Years of Solitude:*

"The final protection, which Aureliano had began to glimpse . . . was based on the fact that *Melquiades had not put events in the order of man's conventional time, but had concentrated a century of daily episodes in such a way that they coexisted in one instant.* Fascinated by the discovery, Aureliano read aloud without skipping the chanted encyclicals that Melquiades himself had made Arcadio listen to and that were in reality the prediction of his execution, and he found the announcement of the birth of the most beautiful woman in the world who was rising up to heaven in body and soul, and he found the origin of the posthumous twins who gave up deciphering the parchments, not simply through incapacity and lack of drive, but also because their attempts were premature." (Emphasis added.)

It is not surprising, then, that photographs are written in the language of the cultures from which they come, that the proclaimed "universal language" of photography does not exist. (The famed 1955 Museum of Modern Art exhibition Family of Man, the most successful photography exhibition of all time, is perhaps most at fault for the simplistic impression that we are all the same and can immediately understand each other through photographs.) One can say that photography in the United States, with its concentration on the object and the material world, represents this culture as does the concrete use of language by Norman Mailer or William Carlos Williams. One might compare their style with the very different sinuousness, élan, and indirection of the French language and French writers, and of that country's photography.

For me the divergence between French and American approaches to photography became evident in 1979 when, soon after becoming picture editor of *The New York Times Magazine*, I wanted to publish a two-page photograph of a rookie baseball catcher, sandwiched between the batter and the umpire, straining his body upward to follow and catch a ball that had been hit straight up. Initially, my request was denied on the grounds that readers needed to see the man's face in an opening pic-

ture. I argued for using the photograph, asserting that it showed something important about the dynamics of baseball and the rookie's earnestness. Since the reader could see his face on the cover of the magazine, why did one have to show it again?

By contrast, at approximately the same time *Paris Match* published a photograph that I envied but felt would not be used as an opening image in a similar publication in the United States. It was a two-page photograph of a helicopter hovering over crowds of people holding up crosses and pictures of the Pope. Even without seeing his face, it was evident that the Pope was in the helicopter—a foreign, distant, somewhat anonymous Pope returning from far away to his native Poland (figure 27).

It then interested me to find how in 1928 the French picture magazine Vu, which preceded Life by eight years, announced its raison d'être in its first issue: "There doesn't exist a picture magazine here which expresses the speeded-up rhythm of present-day life, a magazine that informs and documents all the manifestations of contemporary life: political events, scientific discoveries, disasters, exploration, sports exploits, theater, film, art and fashion. Vu has taken upon itself to fill this gap. . . . Animated like a fine film, Vu will be awaited each week by all its readers." Life, on the other hand, was interested "To see life; to see the world; to eyewitness great events . . ." It was as if, in the case of Life, one could target events, people, and places, and by the act of seeing them "be amazed . . . and be instructed," whereas in the case of Vu one expresses life's rhythms as one informs. This comparison begins to help delineate the emphasis in two terms that, although similar, have been mistakenly used interchangeably: what the French call reportage, which involves the articulation of the rhythm of events, or what Cartier-Bresson refers to in his own work as the "tasting" or "sniffing" of a situation, against the traditional American sense of photojournalism and its less visually dynamic (and more verbal) goal of framing certain targeted objects that have been declared of interest.

One hopes that it may soon be possible to begin to approach photography with a respect for what it is capable of, employing it to parallel words rather than illustrate them, to remain nuanced, saying more than one absolutely needs or even wants it to say, to show in great detail

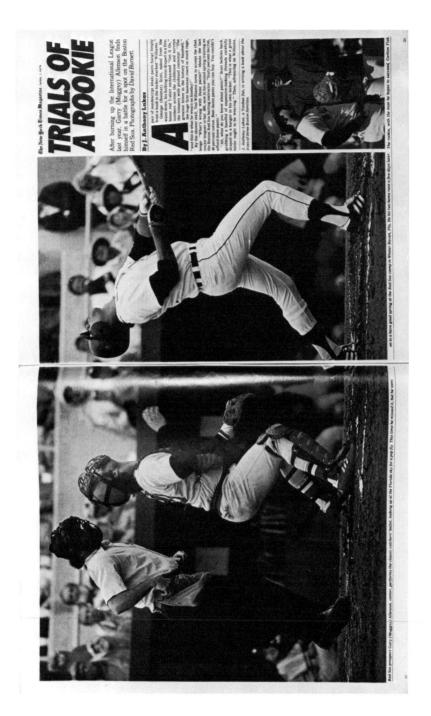

27. The American concept of photojournalism and the French concept of reportage are quite different, the former emphasizing the concrete (one might even say that which can also be asserted verbally) and the latter looking more for visual rhythms. For example, while working as picture editor of *The New York Times Magazine*, one of my first difficulties was in publishing an opening

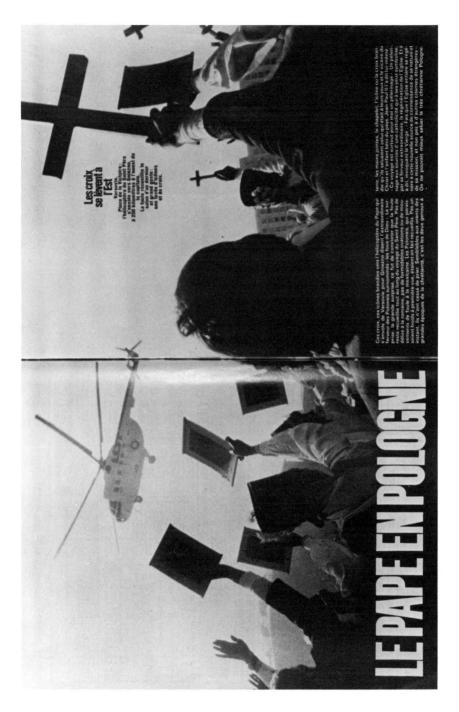

photograph of a baseball player which did not show his face, despite his face already being on the magazine's cover. The French suffer less from this particular problem, such as in the *Paris Match* spread of the Pope, who had come back to Poland. Baseball photographs by David Burnett; Pope photograph by G. Virgili. (Original baseball photographs in color.)

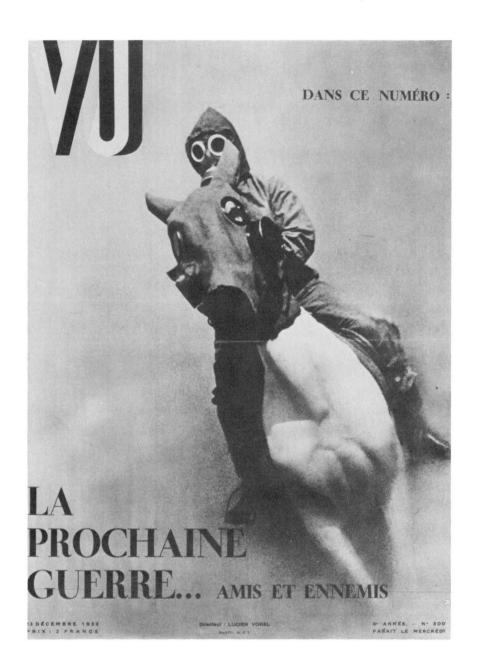

28. France's Vu, a weekly picture magazine, which pre-dated Life by eight years, was created to be a publication that "expresses the speeded-up rhythm of present-day life," while being "animated like a fine film." Vu, December 13, 1933.

what is happening without denying the photographer's point of view, and all the while encouraging people to read images carefully, aware of their propensity to be recontextualized. One wonders if there can be a rethinking of photography, an appreciation of its untapped powers of language once freed from its almost exclusive bondage in the media to "objective" transcription and preconceived illustration. If this were to happen, then the potential applications of computerized retouching systems, incapable of simulating the "presence" of such photography, would be diminished.

One also wonders if those who secretly retouch photographs will then understand that they have been tampering with much more than a secondary, mechanical medium constrained by the myths that surround it. But if such an understanding doesn't take place, and they continue to quietly alter photographs, eventually very few will pay photography any heed at all. Then if someone cries wolf, no one will even know it, let alone come to attempt a rescue.

Authoring the Image

AS IT BECOMES EASIER TO TAMPER with the evidence of the photograph, all those involved in the process of publishing photographs will personally have to vouch for the content of the image. Not only will readers have to depend upon editors to limit and identify their use of image-modification techniques, but with the adoption of electronic cameras and more effective home-computer imaging systems, photographers (those not replaced by robots or video) will have to be trusted to a greater extent as well. Like the writer, the photographer—rather than the mechanical camera—will need to assume responsibility for the content and authenticity of all that he or she reports. Furthermore, the photographer's often minuscule "credit line" will have to become more of an author's byline.

But before that is possible, not only the photographic medium but the photojournalist's role requires reevaluation. Photojournalists face a problem different from that of artists, whose authorship has been unquestioned. We have honored the individualized creativity of the artist at times to the extent of creating a cult of personality. Whether new electronic imaging techniques encourage the artist to a greater freedom, or a facile, derivative fluency, it is clearly up to the artist to assimilate and use the various new media according to personal requirements. But in photojournalism, the medium that may be most compromised by the introduction of electronic imaging technology, there is little sense of the photographer as more than a vulnerable and often passive cog in a well-oiled machine.

Right now the photojournalist is in large measure considered to be someone who provides a multiplicity of imagery for the publication's personnel to select from. The image's contextualization by caption and layout is usually accomplished by others as well. The photographer, pledged to neutrality as a journalist, ends up covering almost everything in pursuit of fairness without being able to finally articulate his or her own point of view. This system is so entrenched that many do not notice its existence. In my experience, one famed veteran photographer was adamant in saying that it is only the magazine that has a right to a point of view, not the photographer. Another respected veteran, asked to select from among his own images by a magazine editor considering the publication of a portfolio of his work, refused, saying that no matter what he thought he would be overruled.

One problem with such a relationship between photographers and editors is that it minimizes the possibility of authorship, and limits photography's urgency and breadth. There is no need for a photographic syntax, to think of photography's various linguistic capabilities, when the photograph is used as neutral raw material for others to mold. It is like handing editors lists of phrases, and letting them put the phrases together in whatever order they prefer. The phrases only have to be exciting—they do not really have to mean anything.

In an ideal system the selection and contextualization of imagery would be made by the photographer and editor in close consultation, utilizing the photographer's intimate knowledge of what actually happened along with the distanced perspective of the editor. Unfortunately this seldom occurs, and many of the more sophisticated photographers working on assignment for magazines, particularly in recent years, accept assignments in large measure to make pictures for themselves, not expecting the more interesting images to ever be used. Part of the problem has to do with the limited power of photo editors representing a medium which is almost everywhere considered secondary to the text. Another part is the limited scope of publications, whose "format" requires that photographs speak in a kind of controlled shorthand.

The photographer's role in all of this is peculiar. It is difficult to imagine asking a writer, for example, to turn in all his or her drafts as one expects a photographer to turn in all contact sheets so that someone else can pick and choose which version to publish. One would generally pay a freelance writer by the completed article, not by the day, buying the rights to all his or her material from a specific time period, as one

often does a freelance photographer. Or, as the French weekly magazine *Paris Match* puts it in its well-known advertising slogan, "The weight of the words, the shock of the photographs."

Obviously, a variety of portraits of someone, or images that depict an event, will express a variety of possibilities. Some of them will be ones that the photographer may not believe in or may have revised in later photographs. The photographer is at the mercy of others, and, wary of this, in self-defense some refuse to photograph the images that the editors of a publication would automatically want. For example, during the 1982 Israeli siege of Beirut some photographers, after discussion among themselves, were said to have decided to minimize their depiction of Palestinians in cowboy hats, feeling that these were the images that would be selected and used in a sensational way to the detriment of the situation's complexity. Many photographers, of course, try to do just what is asked of them; there is at the very least a strong economic incentive.

In June of 1989 a group of about eighty European photographers who work with the press signed a "Manifesto in Defense of Personalized Photography." In it, they articulated a prevalent contemporary position: that the photographer "neither tries to conceal his personality when photographing reality, nor acts merely as a passive agent carrying out an assignment. He doesn't only show us the world as he finds it, but offers us a translation of that world through his pictures." Moreover, the photographer "embraces a point of view that in no way detracts from, but in fact enhances the factual reporting." Intrinsic to that process, the manifesto, signed by photographers such as Henri Cartier-Bresson, William Klein, Marc Riboud, and Jeanloup Sieff, asserts that this "Personalized photography consists of two inseparable steps: the picture-taking and the editing. The latter, the process of reviewing and selecting the images, is absolutely essential. It is truly the photographer's 'last look' at a subject he has undertaken to explore. The act of selecting is an integral part of the photographic process, and reveals, as much as the actual shooting, the photographer's personality and point of view. We ask that all the people responsible (photographic directors, art directors) respect this concept of editing, and by the same token, honor the very quality that impels them to choose one photographer over another."

My own sense of disappointment as a journalistic photographer is traceable to more than a single incident, but one in particular summarizes for me the plight of the photographer and the transmuted reality which he or she is being forced to convey. In 1976 when I was covering the Presidential campaign, I photographed a lunch at Katz's Delicatessen on New York's Lower East Side, famous for its slogan, "Send a Salami to Your Boy in the Army." Two veteran Democrats, New York's Mayor Abraham Beame and Presidential candidate Henry "Scoop" Jackson, sat next to each other eating delicatessen sandwiches, chatting. But they were so crushed by representatives of the press all around them—photographers, reporters, television crews standing on tables and chairs to jockey for a better view—that the situation seemed almost to become a controlled riot, their "private" conversation comical. A television cameraman on the table next to me, maneuvering for a shot, put his foot in the open mustard jar.

The next day, quite excited, I brought photographs of the lunch to a national news magazine for consideration. The editor I spoke with suggested that if my horizontal photograph showing the inanity of the situation was cropped to make it into a vertical, taking out the surrounding press so it looked as if the two men were having a quiet lunch together, it might be publishable. Today's perfection of the photo-opportunity has made the situation even worse.

There are ways in which the introduction of electronic technology may also expand the role of the photographer and his or her part in the journalistic enterprise. Just as the invention of photography helped to free painters from the necessity of attempting to precisely replicate the visible world, it may be that the questioning of the photograph's veracity due to new electronic imaging technologies will allow at least some photographers to change emphases. They may, for example, be able to evolve more quickly from the role of semi-mechanistic transcriber to one in which they serve in a more openly interpretive, multi-faceted role as witness. The ability of the photographer to contradict societal thinking during the Vietnam War, and to raise questions about whether "objective" was not just another term for supporting those in power, has also helped to emphasize the interpretive role of the photographer. As a

result, while corporate control of the mass media has tightened, there has been a profusion of individualized statements by photographers in a variety of alternative and newly vigorous forums.

One example of how the photographer's witnessing role is evolving relates to a photographic essay published in The New York Times Magazine.³ The essay, by the French photographer Gilles Peress, concerned what was occurring in Iran during the lengthy holding of hostages in the United States Embassy. While virtually all the other media representatives congregated in front of the Embassy over a period of months waiting for something to happen, Peress, not speaking the language, strongly conscious of his uninformed status as a foreigner, wandered the country photographing. Since no one really knew what was happening in Iran, and the precipitate return of Khomeini caught the press, diplomats, and government intelligence services by surprise, Peress's avowedly subjective, impressionistic photographs were published. The essay was given the title, "A Vision of Iran," not the more authoritative "Iran Under Khomeini," or "Iran During the Hostage Crisis." Exceptionally, a photojournalist was proclaimed to have his own point of view, and photography was allowed to do more than play a secondary, authenticating role (figure 29). (But even while acknowledging Peress's individual point of view, it still took a total of over fifteen people, including myself as photo editor, to involve themselves in the publication of the six-page essay.)

Peress's images asked questions as to the nature of the reality in front of them, engaging the reader in an open-ended, non-authoritative dialectic. The photographer utilized odd juxtapositions and unconventional angles in a formal approach that reinforces a sense of Iran's difference and complexity as well as the estrangement of the witness. In a book he later published, *Telex: Iran*, Peress adds telexes that were sent to and from his photographic agency to increase the reader's awareness of his role as a foreigner serving a marketplace while also trying to understand what was happening around him. "These photographs . . . do not represent a complete picture of Iran or a final record of that time," he writes in the book's opening pages. One hopes, would like to be able to expect, that in an increasingly complex world such approaches—using photography to pose questions and rethink situations as much as to pro-

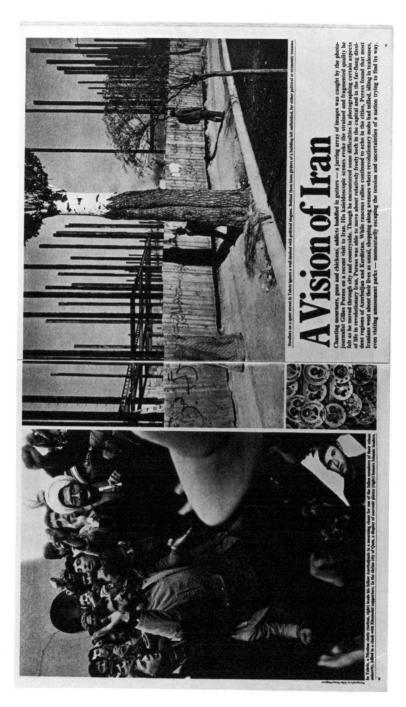

29. It is rare for a photojournalist's work to be used while acknowledging its subjective character. Photographs by Gilles Peress, "A Vision of Iran," *The New York Times Magazine*, June 1, 1980.

vide answers—will be further encouraged. The old photojournalistic refrain of "F-8 and be there" (F-8 refers to a medium aperture for the lens) begins to seem naive. In the future, it may be nearly as applicable to the functions of robot cameras.

In a 1987 public forum at the International Center of Photography in New York, photo editors of major magazines maintained that the only way for a freelancer to have a serious photographic essay appear in their magazines was to first publish it as a small book, and then there was only a remote chance that an excerpt would be published.⁵ It is this sense of having their individual points of view kept out of the publications, and of a general impotence in having any effect, that has led many contemporary photojournalists to turn to venues outside the mass media. As Susan Meiselas, known for her work in Nicaragua since the beginning of the Sandinista revolution, put it, "The larger sense of an 'image' has been defined elsewhere—in Washington, and in the press, by the powers that be. I can't, we can't, somehow reframe it."

It may be time to suggest that there is a classical photojournalism, oriented toward action and a sense of being there, that may increasingly be viewed as simplistic in its approach. Though many major publications have largely abandoned the classical approach for increasingly artificial and staged imagery, some photographers are attempting to extend the original philosophy.

They are trying to remain true to the complexity and power of experience while choosing new approaches to its articulation and in the process expanding the visual vocabulary. Working in large part outside the mass media to better control their work, they have chosen to publish on a smaller scale—in books, audio-visuals, galleries, posters, collective projects, and alternative journals. These serve as a laboratory for a rejuvenated, often personalized, use of photography and a more effective photojournalism, as well as providing an in-depth, accessible history of our time—as recent books on the famine in Africa, the conflicts in El Salvador and Guatemala, and hospital care in the United States demonstrate.

And as prices of the new technology continue to drop and personal computers begin to contain much of the labor-saving technology of the

30. In an age of highly dramatic photographs, it is sometimes the simplest imagery that is the most powerful, as in the *Life* issue in which passport-type photographs of that week's more than 200 American Vietnam War dead were shown. *Life*, June 27, 1969.

million-dollar machines, independents will, in the next few years, be able to benefit from many of the computerized technologies that large publications are now using. Computerization can empower the individual as well, allowing the photographer to contextualize his or her own work, directing the meaning of imagery with text, layout, sequencing, and other presentation techniques in pursuit of new documentary approaches.

When readers have been bombarded by such huge numbers of upsetting images that it becomes difficult for them to focus on, let alone respond to, the newest information, the necessity of divergent strategies becomes evident. For example, the most devastating photographic coverage of the Vietnam War by *Life* magazine was one that essentially turned its back on the battlefront. Its June 27, 1969 issue simply reproduced passport-type photographs of over two hundred young, freshfaced American men who had died the week of May 28–June 3 in Vietnam. Assembled like a high school album, the photographs are, by *Life*'s standards, rudimentary (figure 30). But, according to David Halberstam in his book *The Powers That Be, Life*'s then recently arrived editor, Ralph Graves, was "bothered that in his remaining tenure as editor he had never run anything as important or powerful as this story."

The June 27 issue was the one, after all the action-packed battle photographs, where *Life* was considered to have turned against the war. Certainly without all the preceding images this one issue would not have had nearly the same impact, but if only action images had been published the enormity of the cost of the war, at least on the United States, would not have been so powerfully communicated. Recently *Newsweek* magazine employed a similar gallery approach in documenting month by month some of those who died in one year from AIDS; and in 1989 *Time* used it in a 28-page portfolio depicting those 464 Americans who perished in one week from the use of guns. 8

Similarly, photographers working independently are trying new approaches to broaden and deepen our experience of the world, articulating points of view that publications have not been able to formulate. One can again go back to the Vietnam War for precedents. *Vietnam Inc.*, published in 1971 by Welsh photographer Philip Jones Griffiths, avoids the common depiction of war as high drama. Dramatic images

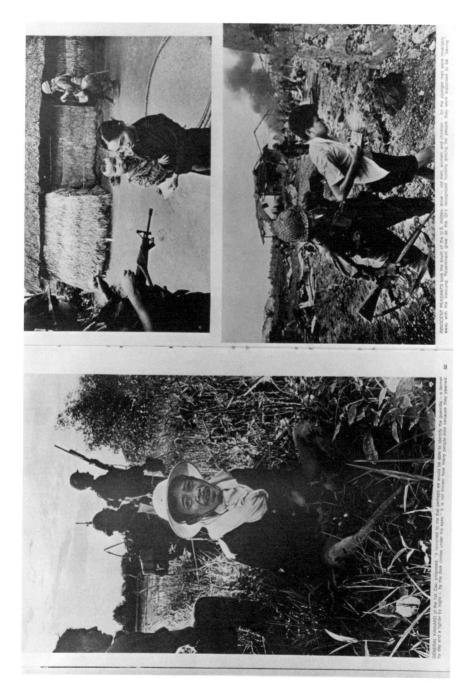

31. Photojournalists in increasing numbers are turning to books in an attempt to control the contextualization of their photographs with text and layout. An early and particularly effective example is Philip Jones Griffiths's 1971 *Vietnam Inc*.

are there, reproduced large—the head of a corpse lying near a gun and a soldier's shadow, a child lost in his grief over a body in the back of a truck, two American soldiers crawling toward a Vietnamese prostitute on the floor, a Vietnamese soldier crouched in amazement and distress over a dead woman on the road, Vietnamese children in a graveyard.

But there are many other images, often of civilians, often less visually striking, used to explore particular facets of the war—a picture of napalm shown next to pictures of napalm victims, apprehensive pedestrians on the street, military personnel with the computer that "proves" the war was being won, men on an aircraft carrier with the caption "They have never seen the faces of their victims, the Vietnamese people," and a photograph of children who are "Orphans visit[ing] a United States Army hospital to sing and dance for the wounded men whose predecessors were responsible for these children's parentless status."

Griffiths, responsible for the book's layout and text as well, is unwilling only to make universal, eloquent pictures of yet another photogenic conflict. Instead, through careful juxtapositions and sequencing of unadorned, sharply observed images, and through his informative, terse, and sardonic text, Griffiths makes a comprehensively detailed and relentless statement that explodes much of the rhetoric surrounding the war (figure 31).

Also avoiding the classical approach to war photography fifteen years later, Sophie Ristelhueber, a Paris-based photographer, went to Beirut and made a small book of images of devastated buildings, photographed as cityscapes. Directly seen, almost surgically depicted, they avoid the oft-seen tragedy of the injured and dead. The unacclimated reader has no ready defense against photographs of buildings, and one is newly aware of the horror of destruction (figure 32). Just as Tom Wolfe, in his book *The New Journalism*, suggested that journalists could borrow from the novel in an attempt to overcome limitations, photojournalists like Ristelhueber have in recent years begun to borrow from the approaches of art photography and vice versa; today's museums are filled with both.

Literature and film have also been inspirations. Veteran photojournalist Raymond Depardon went to Beirut and then to Afghanistan, and published a small book, *Notes*. Interspersed among the photographs of

violence were his notations in personal diary form, a method which he would later use with photographs taken in New York for a French daily newspaper, Libération, and during the French elections for the daily Le Monde. "It rains, it rains," begins a text for Libération's foreign affairs page, with a photograph of three people with umbrellas on New York's Staten Island ferry. "This is Independence Day-it's a festival, the city is empty. A ritualistic visit to the Statue of Liberty. Discussion all night with a girlfriend. I feel like going back to France, to drop everything. I force myself to make a picture. I ask myself what I am doing here. Everything is sad. A terrible day. I begin to read G by John Berger." Unlike conventional newspaper photographs, which concentrate on the anonymous and impersonal, his focus is on daily life and chance encounters. He recounts his experiences through the openly acknowledged subjective feelings of a human being, not the traditionally unsentimental witness. Photography from "out there" becomes tempered by the highly personal, drawing from both public and private spheres (figure 33).

Even more diverse approaches are being tried in recent years by those attempting to exploit the potential of photography to investigate current realities rather than just name them, including work which quite consciously attempts to enfranchise the photograph's subject. There are those, like Fred Lonidier and Allan Sekula, who are acutely aware of problems of subverted communications in this society, and who have attempted to keep the photograph, generally presented with text, squarely on the more "anonymous" subject, such as blue-collar and corporate workers. Their work also serves to critique facile, self-serving cultural and political assumptions in representation.

Another strategy is the introduction of a kind of "documentary fiction" which recognizes the ability to divorce realistic photography from a mechanical transcription of events. In their book *Another Way of Telling*, John Berger and Jean Mohr create a photographic essay about a peasant woman, showing what she might have seen, what might have been important to her. ¹² They announce in the beginning of the essay that this woman never existed, and use the realism of photography in an act of the imagination, uprooting its easy certainties.

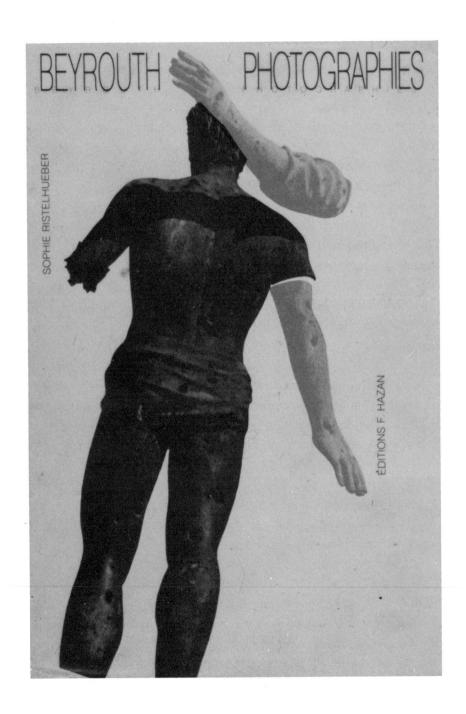

32. Just as the "new journalism" incorporates some of the techniques of the novel, the "new photojournalism" prefers some of the strategies of the art photographer rather than relying on

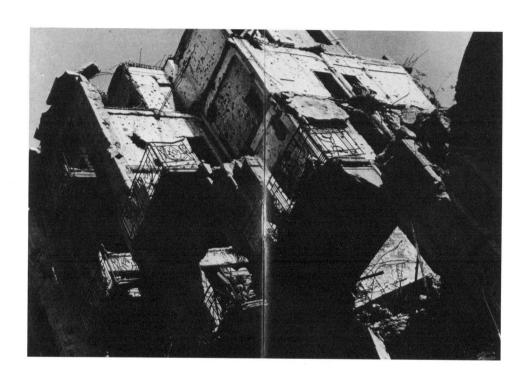

those of what one might now call "classic photojournalism." Sophie Ristelhueber from *Beirut*, 1984.

TUESDAY, APRIL 26, 3 P.M., AVENUE FRANCO-RUSSE IN PARIS

They are all here to support François Mitterrand punctual, Marguerite Duras arrives first she seems to be cold Michel Rocard sits next to her says to her that one must smile The family photo is organized it's like at school Marguerite Duras refuses to speak she poses for a young photographer in front of a poster Why do the handicapped vote for Le Pen? she asks herself, troubled, going out into the street.

33. In recent years a number of photographers have begun to practice journalism in its more personal sense, as in the keeping of a "journal." Raymond Depardon for *Le Monde*.

The computer, which should lend impetus to even more such experimentation, also provides systems that aid a photographer in not only authoring the image, but controlling the whole work. Desk-top publishing systems help the photographer, or anyone else, to become virtually independent in the layout of images and text, and in the formating and eventually the printing of a work as a book, magazine, newspaper, or other form. All contextualization of imagery is done by the photographer. The work can be quickly transmitted to others by modem or fax. The digitization of other media as well makes it possible for the photographer to more easily combine photography with other forms, audio-visuals for example. The upcoming introduction of high-definition television, which offers resolution like that of 35mm photography, will provide another effective forum for the photograph. (A technical problem right now with still imagery on television is that only the more simply composed imagery can be effectively presented.)

Furthermore, the introduction of electronic journals will allow the photographer different kinds of input and the reader/viewer a much more interactive control. For example, one day quite soon you the reader may be sitting at your kitchen table and turn on an easy-to-read computer terminal, perhaps with a screen on one wall, or with screens in several rooms, and begin to peruse a recounting of the events that occurred up until a few minutes before.

The journal you are reading may not be the same as anyone else's because every reader will have been able to program it to reflect his or her own substantive interests and aesthetic tastes. It will be possible to indicate preferred subject matter and layout, and to change one's mind as often as one likes.

Almost certainly readers will ask for a general news roundup, but after that one's primary interests will be highlighted—for example, news from the Middle East, sports, Wall Street, city politics, theater. One might have programmed in a few favorite writers and expect to see their work featured. Or there might be a few key figures to be tracked—let's say the Soviet Secretary of Defense and the Los Angeles Dodgers' third baseman.

But one may also have programmed in much more. In the case of the

34. The flexibility the computer allows for combining words and images, which can be produced in a variety of media and sizes, is one way for the photographer to assert control and become more of an independent author. Esther Parada, *The Monroe Doctrine*, *Theme and Variations*, 1987.

Middle East one might prefer feature pieces to straight news reporting, or a review of what reporters working for Middle Eastern publications have been saying in the last week, perhaps just on oil. In the coverage of Wall Street it might be the long-term financial analyses that are of interest, while in theater it could be serious dramas being performed off-Broadway.

In this scenario, not only will the content be up to the reader, but so will the design. The reader will choose the typeface and the amount and width of columns, as well as the size and number of the pages. Perhaps one will want the headlines to be in different colors, or financial stories in green and foreign stories in red. The reader might also choose to have parts of the journal displayed in moving images—the sports segment, for example—or parts of it read out loud, like a two-minute radio roundup.

The possibilities for photographs will be diverse. The reader can choose to see many images or none at all in the daily news roundup, or to have them precede, follow, or accompany a text piece on the same subject. One might also ask for photographs of favorite subjects, like vacation islands or battles, or preferred photographers or photographic agencies and expect to see all of their work. The reader could ask for bigger or smaller photographs, or more picture stories and essays—even an all-picture publication—as well as the extensive combining of still photography with moving video images. The advent of giant-screen, high-definition television should make it possible for photo essays to once again enter one's living room with a vivid, up-close clarity and freshness they have not had for sixty years.

After selecting the content, one might have one's home computer print out the kind of publication wanted. For example, one might select a 24-page, 9" x 12" full-color journal, with sports on the front page, four pages of photographic essays and a page of poetry, and the review section in the back, and expect to read it on the train. Perhaps there will be programmable vending machines at the corner with laser printers inside.

The stimulation to the field of journalism would be significant. There could be groups of news agencies, newspapers, and magazines offering such subscriber services. It might lead to a tremendous amount of ex-

tended and individualized thinking about things, on the part of both readers and reporters. Each reader would have not only a greater range of information, but also be required to more actively interact with the day's offerings.

In photography, one might be able to see one hundred images from a photographer just returned from Tiananmen Square, rather than the two or three that were being widely distributed. Perhaps, like Depardon's work for the French newspaper *Libération*, one could receive photographic diaries from photographers posted around the world. One might ask for a variety of perspectives on the same event—those by photographers from the host country and the visiting press as well. Similarly, a variety of portraits of a famous person might be available, not just a single choice.

Readers would undoubtedly be able to choose standard design selections as well. Some might want to select a format once, while others would reprogram it constantly. Readers might also be able to type in requests and comments at the end of every day's journal, creating an extensive and perhaps provocative reader-to-reader or "letters to the editor" section.

Part of what this kind of technology allows would be a democratization on a local level of reporting and opinion. People could come together to start their own journals or information services—six poets, for example, or eight members of an environmental group. They could use the technology to reach the public or to communicate only among themselves. Very advanced layouts could be achieved by just pushing a few formating buttons. Those with cameras would also be able to provide their own images of local events, of their families, and share their photographs of a vacation or a business trip.

However, there are potential problems. For example, without a national consensus on what is happening in the world and the country coming from standardized news media, domestic communication and political interchange might lose their focus—although this might also serve to open up the debate. It may become necessary to require that each format a subscriber chooses contain a certain percentage of "main-stream" news. Otherwise, problematic situations would arise similar to the example provided by Stewart Brand in his book *The Media Lab*. In

it he describes Nicholas Negroponte, head of MIT's Media Lab, a group which has been researching electronic journalism among other subjects, telling "an audience at Royal Dutch/Shell corporate headquarters in London, 'If last night Mr. Gadhafi had invaded the United States and also last night you had to cancel this meeting, in my morning newspaper the top headline would be: "Shell Meeting Canceled." Somewhere down below it would say, "Gadhafi etc." In *your* newspaper Gadhafi might have made the headline, but on your front page someplace it would say, "Negroponte Presentation Canceled." To nobody else would the cancellation be news." Brand refers to the journal as *The Daily Me*, a name with disquieting echoes of Paul Stookey's description of the progression from *Life* to *People* to *Us* to *Self* to "Me."

Much of the technology for interactive electronic journalism already exists, although it will have to become cheaper and more efficient. It is a new mindset that is perhaps most lacking, one that would allow us to incorporate these innovations into a new kind of interactive, non-passive communications approach that would transform mass media, as well as the act of reading.

Videotape has also recently become considerably more interactive. "If you are missing televised ballgames you wish you'd seen, or William F. Buckley Jr. holding forth on the latest crisis, SmarTV can find them, tape them and play them back at your command," *The New York Times* reported in 1989 on its editorial page.¹⁴

"If you want, it will zap commercials, too. SmarTV is a soupedup video cassette recorder from the Metaview Corporation of San Francisco. It searches out and tapes programs to suit the viewer's tastes, be they soaps or sports, a favorite author or Bishop Tutu, family issues or whatever. Users profile their interests in answers to a questionnaire, which is then fine-tuned by a personal interview. Thus informed, a Metaview computer scans the weekly schedule, then programs each unit to record what the viewer might want to see. The viewer views at his or her convenience.

"At \$6,000 apiece, SmarTV won't soon sweep the country, but Metaview predicts it will drop to a few hundred dollars if it gets into mass production. That all sounds promising, except for one

thing. If millions plug into a TV system that eliminates commercials, who will pay for the programs they want to watch?"

Many questions have to be asked about the economics of such computer-based communications systems, about the inclusion of advertising and the protection of copyright. Perhaps the greatest question is whether there will be a diversity of news and other information available or whether it will be controlled by a few large corporations. Also, will the individual voices of the journalists and others be allowed to come through, or will information be pooled and homogenized? Because no matter how much of an apparent choice there is, if all of the news comes from and is molded by only a few major organizations, the progress this new technology allows will be only illusory. Of course, computers do allow us, should we desire it, to have a very lively *samizdat* press.

Photographing the Invisible

BALTIMORE, Jan. 15 (AP) —Scientists at Johns Hopkins University, using electrodes connected to a monkey's brain, say they have produced a computer image of the brain as it thinks.

"We have visualized a thought process, a mental transformation," said Dr. Apostolos Georgopoulos, a neuroscientist who led the research team. "We've used a technique that lets a mental process be seen as a physical one. . . ."

SCIENCE FICTION? No. The announcement was made early in 1989, when scientists were able to detect and transform a monkey's brain activity into images of vectors on a computer screen. The images would appear thousandths of a second before the monkey made a movement in the same direction as the vectors. *The New York Times* quietly published the one-column article inside the newspaper headlined, "Computer Depicts Thought Process."

While the above example is certainly rudimentary as to the image produced, comparable in a sense to a cave person's very first scratch on the wall of a cave, it still indicates the scope of the visual revolution that is imminent (figure 35). Photography's reliance on visible light (even scientific photography's use of other wavelengths) begins to appear quite prosaic, even parochial, when compared to the computer's growing ability to use data from any source and represent it as an image, particularly as computer-generated imagery itself begins to look more photographically realistic.

It seems quite probable that in the future boundaries between the visible and invisible will become considerably more permeable. Other

worlds, such as the interior consciousness of animals as well as human thoughts and dreams, prehistory, the sub-atomic world and outer space, may some day be considered the stuff of a new kind of photographic reportage, using what might be called "hyper-photography." One can think of it as a photography that requires neither the simultaneiety nor proximity of viewer and viewed, and that takes as its world anything that did, does, will, or might exist, visible or not—anything, in short, that can be sensed or conceived.

This new kind of photography—able to seamlessly interface with other digital media—will inevitably open up not only new subject matter but new formal approaches as well. Conventions such as one-point perspective may be seen as far too simplistic, and multiple points of view—physical and even psychological—will be possible. Imagery may be made that relates more closely to the human ability to see in context, such as the present in terms of the past, or in unfocused fragments. One may also see in three or more dimensions, or scan a scene, asking for supplementary visual or other kinds of information. The evolving understanding of the world by scientists—the relationship of mass to energy, of space to time, the underlying chaos of nature—and even that of spiritualists, may be factored into this new kind of computer-based photography.

Certainly, hyper-photography requires a leap of the imagination to conceive, comfortable as we are with conventional photography which confines itself to more tangible, verifiable physical realities, albeit realities whose meanings are easily misrepresented. We have faith in the photograph not only because it works on a physically descriptive level, but in a broader sense because it confirms our sense of omnipresence as well—as the validity of the material world.

But what then if we begin to represent photographically that which must exist according to certain laws of physics, things as "real" as the visible even though they are never tangible, to describe certain invisible or conceptual realities? To take a simple example, let us imagine a hyper-photograph of a 40-storey building in a 600-mile-per-hour wind, twice the speed of the highest recorded wind on the earth's surface. It is now possible, using mathematics, to see on a computer screen what

35. Using a computer, scientists have been able to depict a thought process. In this case the vectors represent the visualization of directional thinking by a monkey made a fraction of a second before it moves. A.P. Georgopoulos, Johns Hopkins University School of Medicine, reproduced on the cover of *Science*, January 13, 1989. (Original in color.)

would happen to the building. One factors in the numbers and the program makes a rendition of the building in such a high wind.

Although the image may not be at this point of photographic realism, one wonders why in the future this picture might not be titled, "A Hyper-Photograph of a Forty-Storey Building in a Six-Hundred-Mile-an-Hour Wind." Although this incident never happened, if it did this is what it would look like—or this is what a Martian would look like if he or she, or it, exists, based upon all available data we possess from Mars.

Such an image would not be like the artist's sketch we are familiar with, and which we can easily reject because it appears to be so heavily influenced by human imagination. It is more difficult to reject an image of photographic quality, with its formal connotations of being taken from reality. It will be even more difficult to do so if computer-generated images of people begin to star in films and on television, humanizing them, making them less bizarre, or if entire realistic computer-generated movies come into being, such as one that filmmaker John Whitney Jr. proposed on the lives of dinosaurs. Created completely by computer without human interference, the film would be based only on the data fed into it, such as what we know about prehistoric meteorological conditions, vegetation, and dinosaur anatomy.

Furthermore, and perhaps most persuasively, it may be increasingly difficult to reject such an image when it comes from the reasoning of a powerful, supposedly impartial computer, able to reason more comprehensively than any human being (even if such reasoning was originally based upon programs made by limited, subjective humans). Conventional photographs, which often appear to be arbitrary in their recording of appearances and lack the logic of the computer, may appear from this perspective to be happenstance, even flighty, overly influenced by human bias.

This comparison would be much like that made between nineteenth-century painting and the new medium of photography. Now it is computer technology spawned by the information age that is broadening and taking over some of the functions of a machine, the camera, that came out of the industrial age. The camera, in turn, had partially replaced the paint brush and canvas, a simpler, more naturalistic extension of the human body. Yet the newer media, both the camera and computer,

despite their increasing sophistication, will continue to reflect the biases of human beings—unless one day a computer's intelligence truly becomes its own.

Undoubtedly hyper-photography will feature a variety of approaches to representation, benefiting as well from the computer's ability to make possible a multiplicity of forms of presentation. Continuing from the first example, it seems evident that more complex imagery will be made of the thinking process of animals and then possibly that of humans as scientists begin to understand them better. The computer's ability to easily transform an image from one form to another—as is being done right now by a firm in Toronto, experimenting with software that changes a color photograph into a watercolor or oil painting²—may be helpful in representing thoughts or dreams, which may require the simultaneous presence of a variety of different modes of depiction, such as black-and-white and color, or both sharply detailed and smudgily impressionistic imagery.

This multi-faceted ability of the computer would inevitably alter the way we think about our internal, private, so far rather ephemerally conceived consciousnesses. Today's camera, so often criticized for its invasive disrespect of privacy, might seem remarkably circumspect in comparison (just as earlier painting seems highly respectful of the sitter when compared with photography's ability to "show all"). In this scenario, even the extreme characterizations of a photographer like Diane Arbus might be seen as comparatively tame.

Still, such photography may be based at least partially upon an empirical sense of things, trying to monitor brain waves or other impulses and translate them into images that correlate with the visualization that occurs in the subjects' minds. As such, it might be somewhat like conventional photography, which attempts to depict situations in ways that are perceived similarly by the viewer. Yet hyper-photography of those things that cannot be seen—the world of sub-atomic particles, for example—may not use the commonplace language of sight that photography has accustomed us to, but may perhaps introduce to us another vocabulary of imagery, such as a pictography more like X-rays and laser-light displays that is more pertinent to, let us say, depicting the air itself.

Even in these cases, hyper-photography may inform similarly to photography today, through its representation of appearances and newly articulated visual relationships and metaphors. Nancy Burson's composite image of the heads-of-state of the United States and the Soviet Union, visually weighted according to each country's number of nuclear warheads, may be seen as an early form of this genre (figure 36). Hyper-photography may provide different points of view of even contemporary events if, to go back to an earlier argument, a computer is programmed to show the life of a small village in El Salvador and depict village life at least somewhat according to a statistical average, rather than concentrating on the sensational violent moments.

The computer also invites a return to a universe where certain laws, divine or not, are thought to control life. The visualization of such laws can become a way not only to rethink the essence of what we are used to seeing, but to link things that otherwise seem disparate. For example, there are now theoretical mathematicians who, rather than confine themselves to juggling abstract concepts in their heads or to pencil and paper, have begun to use computers to see what their theorems "look" like, to see how their intuitions are visualized (similar bumps, for example), in order to better understand their essential properties.

It was from just such plotting that Benoit Mandelbrot, a scientist associated with IBM, discovered that his curves were looking not only like each other but like certain natural phenomena—rocks, mountains, skin. His new form of geometry, fractals, is now highly valued in the computer-generated film industry, among many other applications (the planet burning up in Star Trek II, for example, was produced using fractal geometry).⁴

One can imagine a variety of phenomena resembling each other when digitally transformed into visual imagery: a Beethoven Symphony may perhaps resemble a photograph by Ansel Adams (or the opposite; in digital form, one can also "play" an Ansel Adams photograph). On a grander scale, it is impossible to guess what resemblances will emerge. Certain aspects of theoretical physics when visualized may resemble some aspects of conceptual psychology. People searching for harmonies in the universe—physical, spiritual, emotional—may find this methodol-

36. In a digital environment, imagery can be made to represent other data in a variety of new ways. Weighting her image to the "number of nuclear warheads deployable by each country," the artist made a composite figure which is 55% Reagan, 45% Brezhnev, and less than 1% each Deng, Mitterrand, and Thatcher. "Warhead I," by Nancy Burson with Richard Carling and David Kramlich, 1982.

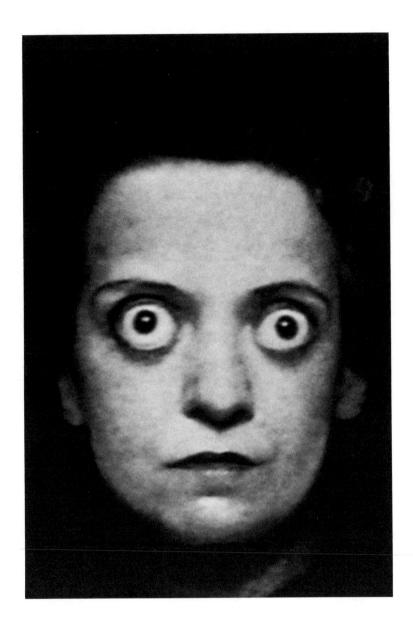

37. Using archival photographs, artists can now electronically composite them to come up with new imagery. We will undoubtedly begin to see a great deal of "second-generation photography." "Untitled" by Nancy Burson, 1988.

ogy productive. Worlds may also be created that are as internally consistent as our own but extraordinarly disturbing: Escher drawings unraveling upon themselves, for example. It may all lead to nothing more than an interesting alchemy, or a dangerous one.

As a part of the digital era, the hyper-photograph will interact with much greater ease and flexibility than the conventional photograph has been able to with other media. It will be able to engage in a discourse with the audience as well, allowing a variety of new strategies for both the producers and the viewers. Eventually, as the medium becomes more interactive, the spectator will also be the producer, at least in part, of that which he or she is seeing.

Anything that can be scanned into the computer or represented by a program will be usable by the hyper-photographer or any other interested party to create and modify imagery, from grocery lists to data from the next galaxy. In an age in which all information can be represented visually, or by any other medium, there is a potential for a sense of universal fluidity, as old barriers separating forms dissolve digitally.

Eventually, it is quite possible that the various media we refer to now—music, painting, photography—may meld into one great hybrid hyper-medium in which each uses and borrows from the others to such an extent that the differences are no longer relevant. Other forms may emerge, making these old categories meaningless, as to an extent has happened with the recent emergence of performance art.

But for the near future one may consider a variety of more or less photographic modes of production and presentation, many of which are technologically possible now, or will be shortly: programs that implement the tonal range of whichever photographer or genre one admires, such as nineteenth-century albumen prints, complemented by the capability to make brush strokes like Van Gogh and to use the lighting of Rembrandt; cameras programmed to photograph like certain acknowledged masters—the decisive moment of Henri Cartier-Bresson is an idea already being bandied about in the photographic community; or photographs that respond to questions or requests, or modify themselves depending upon a variety of different stimuli.

The cartes de visite, the photographic images sold a century ago, spe-

cializing in portraiture, exotic locations, and warfare, might be brought back, only this time electronically. Images may be made to respond to the viewer's questions, showing different scenes or responding verbally or with sounds. This strategy could help to combat some of photography's propensity to decontextualize. For example, while showing the famous 1968 photograph by Eddie Adams of the point-blank assassination of a Viet Cong officer, one might always have electronically imprinted with it the reasons why the shooting is said to have occurred (Adams was recently told by several sources that, rather than being an arbitrary shooting, the man firing the gun had just found out that his best friend's family had been massacred and the man he was executing was responsible), what happened to the man who did it (Nguyen Loan now owns a restaurant in the United States), and other important information that would be retrievable by an interested viewer including its date, where it happened, and the identity of the photographer who took it. (In this case a photograph heralded as a symbol of the senselessness of the Vietnam War may have to be reconsidered if in fact its context was that of a personal revenge.) Photographs preceding and following it on the contact sheet might be retrievable as well.

Should one go to a museum, there may simply be rectangles, or other shapes, and, depending on the number of the people in front of it, or the noise level, or the time of day, certain images might be made to appear. The rectangle could ask questions, and depending on the answers generate partially different or completely new imagery. For example, one might need to be as small as a child, or with a child's voice, or a child's innocence, to see certain "secret" imagery. Or, as an anti-voyeuristic step to preserve the subject's privacy, only people who demonstrate enough knowledge about a certain person might be permitted to see relatively intimate images of him or her, both in museums and in electronic journals. Stephen Axelrad, a programmer in California, has created an interactive artwork called "Self Search" in which the viewer can continually replace elements in a photograph. Meanwhile, based upon their selections the computer discreetly learns enough about the viewers' photographic preferences to limit their range of choices, becoming "smarter" than the viewer without letting on.

Future developments in artificial intelligence might allow for a variety

of other possibilities. For example, using two-dimensional photography or three-dimensional holography and computers programmed with someone's "personality," one could invite the person over for a chat. Robotics, of course, brings up these dreams/nightmares most concretely, but the ability of filmmakers, as in video games, to begin to incorporate the viewer imagistically and linguistically into the action raises issues that may become visually real before, if ever, possible in robotics.

Much of our choice in visual technology is, of course, dependent upon our world view. It is no accident that along with the invention of photography 150 years ago came the electric clock and locomotive. Like them, photography serves to delineate time and enlarge our sense of physical access. Nor is it an accident that hyper-photography has come into being in an age marked by volumes of information, where the dreams and hallucinations of television and Wall Street have enveloped society and become more real than the depletion of trees in the forest, where the life of the collective takes place as much in the solitary musings of its members as elsewhere.

From the vantage point of future possibilities, photography as we have known it begins to seem extraordinarily modest and faithful to that which we can generally agree upon, the physical appearance of things. And just as photography helped to describe and change perceptions of the visible world, it seems probable that a new hyper-photography will arrive to describe and alter our sense not only of that world but of those beyond it. Photography, for 150 years basically a perceptual medium, can now become a largely conceptual one as well.

In Our Own Image

WE HAVE FOUND THE GENIE that can, on paper, make each of us the beautiful princess or handsome prince, and the other the ugly duckling. With the advent of electronic technology, photography has the capability to become a vanity medium, providing us with a precisely controlled view packaged as perception. Those in power can take advantage of its enhanced capability to deceive and more expertly project their own worldview, camouflaging it as reporting.

Recent technological developments, as should by now be clear, are not themselves creating radically new representations of the world. Photographs have long been used to illustrate preconceptions. They have long been decontextualized, misdirected, cynically relied upon to confirm certain values by those who control their use. With or without utilizing the computer, in recent years mass media photography is retreating from its democratic, exploratory potential. It is becoming a language at the service of power with a limited vocabulary, artificially opaque rather than translucent in its approach to the world. Photographs of this sort do not require a careful reading to interpret them at their various levels of meaning because they have been shorn of all but a predigested message.

What electronic retouching technology allows is for this to be done better than ever before. For the first time, it gives those who have access to the technology the ultimate weapon, one that renders the photographer, even the subject, virtually powerless. The reader, unable to detect the alterations, can be deceived most of all.

Photography's highest function has never been the telling of unmediated truths, but rather its engagement in a dialectic with human beings.

A photograph can suggest that we look harder at the realities surrounding and permeating us because they are insufficiently grasped. When stopped and studied, when looked at in great detail, particularly when seen less filtered by normative cognitive hierarchies, the photograph often asserts that much more is going on than we might otherwise have thought. Through its irrefutable depiction of physical reality (we can see "it," "it" exists) the photograph has also up to now carried an automatic and visceral weight that only film and video (which themselves are photographs in motion) can begin to match.

One would therefore be incorrect to assume that the application of electronic retouching necessarily makes a photograph a lie (although if acknowledged it does lessen the image's immediacy), just as the photograph itself is not automatically the truth. It is the deception that the altered photograph contains only what the lens has recorded on film that is the lie. But it is an untruth as well to pretend that the photographic representation, even if directly recorded, is the reality itself.

Both approaches underestimate the capability of photography to engage itself otherwise, less obviously, in subtle ambiguity, in soaring metaphor, in questioning the nature of reality rather than delineating conventional responses. They also overestimate the power of the technology—saying that "the camera never lies" is as foolish as asserting that the computer always does.

But the new technology is helping us, forcing us, to redefine our relationship to the photograph, just as 150 years ago painting was redefined from a medium that emphasized visual verisimilitude to one that explored subjective human consciousness and the vagaries of perception. The photograph, held up as the more efficient inheritor of the replicatory function, has survived the advent of both Freud and semiology; its reputation for fidelity remains largely intact in the popular imagination. But the computer is already being used in ways that are sure to undermine such a reputation. People do not like to feel tricked.

Thanks to the capabilities of electronics, photography is less dependent on any single manifestation of reality, on any one specific time or place. Its selective, analytic bias is being eroded in favor of an increasingly synthetic one. It is quite possible that the emphasis on visible real-

ity and its replication will diminish and become part of a limited genre, as it did in painting, replaced by emphases on simulated, imaginary, invisible, and conceptual realities.

In the field of photojournalism it is clear that journalistic principles and not vague photographic mythology must be invoked in attempting to maintain both an active role for the photograph and the public's confidence. Such a clarification should encourage a belated acknowledgment of photography's subjectivity and range, its different uses, approaches, sources, and ambitions. Photographs will have to be treated less monolithically, with the understanding that, like words, images can be used for a variety of purposes and can be produced according to different strategies. They may be factual or fantastic, reportorial or opinionated. Just because words can be fictional does not require the outlawing of news articles; similarly with photographs. The initial clarification that is needed is the separation of one kind of communication from the other, properly labeled. Otherwise the reader may begin to assume that every photograph is altered.

These new developments represent both openings to new knowledge and an invitation to its constriction. It depends upon how photography is understood, is itself represented, and who controls it as to whether it succumbs, as does much of mass communication, to meaningless proliferation of data and the dissemination of overriding preconceptions ever more cleverly camouflaged as valuable information. It is a problem that, among other dimensions, is intensely political, challenging the premises of a democracy which requires informed voters.

But photography's problem is also one peculiar to imagery. Photographs are considered highly important sources of information but there is no requirement of literacy, from either those who view them or those who control their use. Just as few would think to apply journalistic standards to the *Rain Man* composite image of two actors (could one ever in a journalistic text assert that two men were together when they were not?), few have tried to figure out the meaning of photographs, or even to take seriously their capacity for meaning. Advertisers, who put the pretty woman next to the car they are trying to sell, utilize an implied logic that, being nonverbal, is left unchallenged. Perhaps that is partially why photographic literacy is not encouraged—illiteracy works so

well for advertising (including the advertising of the publication itself). If one knew how to read the images, the so-called subliminal messages of advertising would be much more obvious: "Buy this car and the pretty woman will like you" is considerably less convincing when put bluntly.

Laszlo Moholy-Nagy's 1936 statement, "The illiterate of the future will be ignorant of the use of camera and pen alike," has come true without our acknowledging it. The issues raised by electronic technology become that much more difficult to grapple with if one does not take the photograph itself seriously. One hears much of the filmmaker not being understood by Hollywood producers, so much so that it has become a cliché, but the photographer is also not understood, particularly by those who think of literacy as only verbal. It is by far a more common problem, one affecting most of us on a day-to-day basis. Leaders in the photojournalistic community have an obligation to raise these issues.

There are a few innovators, fluent in photography, some of them mentioned earlier, who are working on the fringes to pursue new strategies to amplify our understanding of the world while broadening the reach of the medium. If they were a literary movement, more attention might be paid to them in cultural publications; one might even feel somewhat embarrassed about not knowing what they were doing. Their task is also made that much more difficult because in the modern world it is the perspectives of creative individuals that are far more likely to be labeled dangerously "subjective" than those of corporate entities, whose views are considered comfortably "objective."

In general, electronic journalism promises more of a diversity of opinion and interchange outside of the traditional channels, depending of course on who or what controls these new channels. The computer, through desk-top publishing, is useful in helping the photographer become more self-sufficient, an independent artisan working within the anonymous information age. As image-manipulation technology becomes cheaper, the individual practitioner will also have to confront the various aesthetic, ethical, and journalistic dilemmas that editors on large publications are now facing.

However, the newest frontiers that the computer opens are those be-

yond the usual reach of the conventional photographer, those that emphasize conceptualization as an approach to imagery rather than perception. Precisely representing the invisible in the language of sight can make it possible to describe and comprehend realities and their interrelationships that until now have remained abstract and amorphous. Once again it would be wrong to assume that the mechanical bias of the computer guarantees objectivity in these new descriptions, just as the camera could never guarantee it. But we must be ready for a new kind of image-making that can provide another alternative, turning from improving our own self-image to exploring territories that exist independently of us, both inspiring and disturbing.

Finally, the primary question has to be addressed to ourselves as a society. Will we put the new technology to use recycling what we already know or use it to attempt new understandings? To what extent will these technological advances be employed to enhance the development of a derivative, postmodern culture, devouring its own past as it substantially alters our own collective memory? To what extent will they be used to control us, or self-aggrandizingly to promote a "God complex" among their users?

We have before us a rare chance to discuss a new beginning, or at least an exhilarating turn. One hopes that the discussion will not simply blame or applaud the technology for all that is, and will be, happening to photographic imagery. The discussion should question the nature of photography and its potential role in our evolving society. Will we use photography to respect and value the complexity of the other, whether another person, place, people, idea, or the other that exists in ourselves? Or will we opt for a vanity medium until the world becomes, imagistically, a highly claustrophobic place? It is up to us, if we can, to take advantage of the new technology's potentially illuminating perspectives; otherwise, it will be we who are taken advantage of and diminished, frozen in our own image.

NOTES

THE PIXELLATED PRESS

- 1. "Who's On First?" *Newsweek*, January 16, 1989, pp. 52–53.
- 2. Clare Ansberry, "Alterations of Photos Raise Host of Legal, Ethical Issues," *The Wall Street Journal*, January 26, 1989, p. B1.
- 3. In order to provoke discussion at a National Press Photographers' Association conference at the Rochester Institute of Technology on March 25, 1988, Cartwright and printing specialist Blair Richards faked a miniaturized *National Geographic* cover showing Reagan and Gorbachev together looking at their watches in Moscow, and entitled it "Waiting for the Summit." Having sent Reagan a copy of the fake, Cartwright received in return another photo of Gorbachev and the President, which Reagan signed, "With appreciation, every good wish and very best regards."
- 4. National Geographic, February 1982.
- 5. Rolling Stone, March 28, 1985.
- 6. Rick Smolan and David Cohen, eds., *A Day in the Life of America* (New York: Collins Publishers, 1986).
- 7. Robert F. Brandt, "Technology Changes, Ethics Don't," *presstime*, December 1987, p. 32.
- 8. Quoted in Marianne Fulton, *Eyes of Time: Photojournalism in America* (Boston: New York Graphic Society, 1988), p. 246.
- 9. The photograph appeared in Nicholas Gage, "My Mother Eleni," *The New York Times Magazine*, April 3, 1983, p. 21.

- 10. "New Picture Technologies Push Seeing Still Further From Believing," *The New York Times*, July 3, 1989, p. 42.
- 11. The montage appeared in *Time*, April 20, 1987, pp. 14–15. Drapkin was quoted in "The Future of Photography," *Photo/Design*, May/June 1988, p. 82, excerpted from a panel discussion organized by the American Society of Magazine Photographers.
- 12. Quoted in Ansberry, op. cit.
- 13. Quoted in ASMP Bulletin, March 1989, from a panel discussion on "Electronic Imaging and the Future of Photography," held at the New York Public Library on January 11, 1989, sponsored by the Polaroid Corporation.
- 14. "The Future and You," Life, February 1989.
- 15. Roger Armbrust, "Computer Manipulation of the News," *Computer Pictures*, January/February 1985, pp. 6–14.
- 16. Producer Sid Feders quoted in Bill Carter, "ABC News Divided on Simulated Events," *The New York Times*, July 27, 1989, p. C20.
- 17. "Mickey's New Magic," Newsweek, April 3, 1989.

COMPUTERS DON'T KILL PEOPLE

- 1. Quoted in Philip B. Kunhardt, Jr., ed., Life: The First 50 Years 1936–86 (Boston: Little, Brown and Company, 1986), p. 5.
- "This is War!" Picture Post, December
 1938.
- 3. Wilson Hicks, Words and Pictures: An

- Introduction to Photojournalism (New York: Harper and Brothers, 1952), p. 128.
- 4. Carolyn Forché, *El Salvador: Work of Thirty Photographers*, eds. Harry Mattison, Susan Meiselas, and Fae Rubenstein (New York: Writers and Readers, 1983).
- 5. "Giving Peace a Chance," *Time*, and "Does Peace Have a Chance?" *Newsweek*, both October 29, 1984.
- 6. John Szarkowski, *Mirrors and Windows: American Photography Since 1960* (New York: The Museum of Modern Art, 1987), p. 14.
- 7. Hicks, op. cit., p. 129.
- 8. Ibid., p. 130. Photographer Smith's point of view is also cited: "If to direct is to translate the substance and spirit of the actuality more effectively, then it's thoroughly ethical. If, however, the actuality is perverted for the purpose of making a more dramatic picture, the photographer has indulged in an unwarranted 'poetic license.' This is a common type of distortion."
- 9. Albert Scardino, "Glimpsing a Day When No 2 Copies Will Be Alike," *The New York Times*, April 24, 1989, p. D9.
- 10. Douglas Kirkland, "The Bishop at Ground Zero," *Life*, July 1982, pp. 62–63.
- 11. Photographed by Grey Villet, reported by Susan Peters, text by Martha Fay, "'I Am A Coke Addict': What Happens When Nice Guys Get Hooked," *Life*, October 1986.
- 12. Photographed by Bill Eppridge, written by James Mills, "We Are Animals in a World No One Knows," *Life*, February 26, 1965. An additional article on treatment possibilities for addicts appeared in the March 5, 1965, issue of *Life*.
- 13. Quoted by Vicki Goldberg in *Margaret Bourke-White* (New York: Harper and Row, 1986), p. 174.

BRINGING BACK MARILYN

1. Rebecca Hansen, "Computers and Photography," *Computer Graphics World*, January 1989, pp. 53–60.

- 2. "3-D Maps for Surgeons," *Life*, June 1989, pp. 45–46.
- 3. Joseph Deken, *Computer Images: State of the Art* (New York: Stewart, Tabori and Chang, 1983), p. 97.
- 4. Stewart Brand, *The Media Lab: Inventing the Future at MIT* (New York: Viking, 1987), p. 259.
- 5. Chuck Scarborough and William Murray, *The Myrmidon Project* (New York: Coward, McCann and Geoghegan, 1981).
- 6. Philip Elmer Dewitt, "Through the 3-D Looking Glass," *Time*, May 1, 1989, pp. 65–66. The prediction comes from Jim Clark, chairman of Silicon Graphics, described as "the leading manufacturer of 3-D workstations."
- 7. "This Picture is a Fake," *Science 84*, August 1984.

READING PHOTOGRAPHS

- 1. "Speaking of Pictures," *Life*, March 10, 1947, pp. 20–22. An abridged version appeared in Virginia Adams, *Crime*, Human Behavior Series (New York: Time-Life Books, 1976), pp. 44–45.
- 2. "Capital Comment," Washingtonian, June 1979, p. 15, reports on the unusual series of cropped photographs in the Washington Star on March 27, 1979.
- 3. Photographs by William Strode, article by Benno Kroll, "The Savage Pit," *Geo*, November 1979.
- 4. The "Falling Soldier" image was first published in France in *Vu*, September 23, 1936, and in the United States in *Life*, July 12, 1937.
- 5. Phillip Knightley, *The First Casualty* (New York: Harcourt Brace Jovanovich, 1975), pp. 209–212.
- Richard Whelan, Robert Capa (New York: Alfred A. Knopf, 1985), pp. 95–100.
- 7. Henri Cartier-Bresson, *The World of Henri Cartier-Bresson* (New York: Viking, 1968), preface.
- 8. Gabriel García Márquez, One Hundred

Years of Solitude (New York: Avon Books, 1971), pp. 382–383.

9. Vu, March 21, 1928, p. 11. Translation by Carole Naggar and the author.

AUTHORING THE IMAGE

- 1. See Fred Ritchin, "Beirut: The Photographers' Story," *Camera Arts*, January 1983.
- 2. It was intended that the association would eventually be expanded to include non-European photographers and to begin bestowing awards on deserving photography and art directors. For more information about Droit de Regard, one may contact Patrick Zachmann, 28, rue de Fecamp, 75012 Paris, France.
- 3. Gilles Peress, "A Vision of Iran," *The New York Times Magazine*, June 1, 1980, pp. 40–45.
- 4. Gilles Peress, *Telex: Iran/In the Name of Revolution* (New York: Aperture, 1983).
- 5. Forum on "The Future of Photojournalism," co-sponsored by Contact Press Images and the International Center of Photography, held at the International Center of Photography Midtown, New York City, April 7, 1987.
- 6. Susan Meiselas and Fred Ritchin, "The Frailty of the Frame," *Aperture*, no. 108.
- 7. Quoted in David Halberstam, *The Powers That Be* (New York: Dell, 1980), pp. 675–677.
- 8. "The Face of AIDS: One Year in the Epidemic," *Newsweek*, August 10, 1987; "Death by Gun," *Time*, July 17, 1989.
- 9. Philip Jones Griffiths, *Vietnam Inc*. (New York: Macmillan, 1971).
- 10. Sophie Ristelhueber, *Beirut* (London: Thames and Hudson, 1984).
- 11. Photographed for *Liberation*, Paris, France, between July 2–August 7, 1981. Excerpted in Raymond Depardon, "French Postcards," *Camera Arts*, March 1983, pp. 6–10.
- 12. John Berger and Jean Mohr, Another Way of Telling (New York: Pantheon, 1982).
- 13. Stewart Brand, The Media Lab: Invent-

ing the Future at MIT (New York: Viking, 1987), pp. 37–38.

14. "Personally Tailored TV," *The New York Times*, April 2, 1989, p. 30.

PHOTOGRAPHING THE INVISIBLE

- 1. The discovery was first reported in *Science*, January 13, 1989. *The New York Times* article, "Computer Depicts Thought Process," was an Associated Press dispatch that appeared on January 16, 1989, p. A11.
- 2. ImageWare in Toronto produces software called ImagePaint that, according to the company, can "take a digitized image and render it to look hand-drawn in any number of classical drawing and painting styles—from water colour, oil, charcoal, pencil, crayon, pastels, ink and lithography to more exotic special effects such as reflective chrome and refractive glass models."
- 3. See Nancy Burson, Richard Carling, and David Kramlich, *Composites: Computer-Generated Portraits* (New York: Beech Tree Books, William Morrow, 1986). Their work has also been used in the search for missing children, providing composited imagery of what a child might look like years later.
- 4. See Benoit B. Mandelbrot, *The Fractal Geometry of Nature* (New York: W.H. Freeman and Company, 1983).
- 5. It is interesting to consider that Ansel Adams trained as a concert pianist and invented a means of categorizing the tonal range of photographs according to a "zone system" that is very much like the musical scale.

IN OUR OWN IMAGE

1. Laszlo Moholy-Nagy, "From Pigment to Light," *Telehor* 1, no. 2 (1936). Reprinted in *Photographers on Photography*, ed. Nathan Lyons (Englewood Cliffs, N.J.: Prentice-Hall, 1966), pp. 73–80.

Note: Interviews with the author, which are not footnoted, took place between 1984 and 1989.

PICTURE CREDITS

Front cover © 1988 Pixar Frontispiece © 1987 Freddy Alborta/ Contact Press Images Back cover © 1990 Nancy Burson and David Kramlich

CHAPTER 1

Fig. 1: cover © 1989 New York News, Inc.

CHAPTER 2

Fig. 2: spread © 1989 Newsweek, Inc., image by Douglas Kirkland/Sygma

Fig. 3: © 1989 Douglas Kirkland, from Light Years: Three decades photographing among the stars (New York: Thames and Hudson, 1989)

Fig. 4: cover © 1982 National Geographic Society

Fig. 5: courtesy Guenther Cartwright

Fig. 6: cover © 1985 Straight Arrow Publishers, Inc.

Fig. 7: cover © 1986 Collins Publishers (calendar); cover © 1986 Randd, Inc. (book)

Fig. 8: spread © 1989 The Time Inc. Magazine Company

Fig. 9: © 1984 Gianfranco Gorgoni/Contact Press Images (original photograph); photographs in composite image by Gianfranco Gorgoni/Contact Press Images (Skyline), Jean Claude Lejeune/Black Start (Eiffel Tower), Steve Proehl/Image Bank (Transamerica Building), J.P. Laffont/Sygma (Statue of Liberty). Composite made on Scitex Response Computer System at Scitex

America Headquarters in Bedford, MA., image © 1984 Fred Ritchin © 1984 Sarah Putnam (Empire State Building).

CHAPTER 3

Fig. 10: Picture Post, December 3, 1938

Fig. 11: Photographs © Susan Meiselas/ Magnum, from El Salvador: Work of Thirty Photographers (New York: Writers and Readers, 1983)

Fig. 12: spreads © 1984 Time, Inc. (*Time* magazine) and © 1984 Newsweek, Inc. (*Newsweek* magazine).

Fig. 13: cover © 1982 Centre Georges Pompidou/CCI, Paris

Fig. 14: spread © 1982 Time, Inc.

Fig. 15: cover and spreads © 1986 Time, Inc.

Fig. 16: spreads © 1965 Time, Inc.

CHAPTER 4

Fig. 17: © 1989 Canon USA, Inc.

Fig. 18: V. Michael Bove, Jr.,

© Massachusetts Institute of Technology

Fig. 19: © 1988 Pixar

Fig. 20: © 1989 Kleiser-Walczak

Fig. 21: Computer-generated image of billiard balls by Thomas Porter based on research by Robert Cook, © 1984 Lucasfilm, Ltd.; photograph of hand by Gordon Gahan/PRISM; cover © 1984 American Association for the Advancement of Science

CHAPTER 5

Fig. 22: spread © 1976 Time, Inc.

Fig. 23: spread © 1979 Washingtonian magazine

Fig. 24: spreads © 1979 Gruner & Jahr USA,

Inc.

Fig. 25: © Robert Capa/Magnum Photos

Fig. 26: © 1980 Maria Eugenia Haya

Fig. 27: baseball spread © 1979 The New York

Times; Pope spread © 1979 Paris Match.

Fig. 28: Vu magazine, December 13, 1933

CHAPTER 6

Fig. 29: spread © 1980 The New York Times

Fig. 30: © 1969 Time, Inc.

Fig. 31: © 1979 Philip Jones Griffiths/

Magnum, from *Vietnam Inc*. (New York: Macmillan, 1971).

Fig. 32: © Sophie Ristelhueber, from *Beirut* (London: Thames and Hudson, 1984)

Fig. 33: © Depardon/Magnum/Le Monde

Fig. 34: © 1987 Esther Parada

CHAPTER 7

Fig. 35: A.P. Georgopoulos, Department of Neuroscience, Johns Hopkins University School of Medicine, Baltimore, MD 21205; cover © 1989 by the American Association for the Advancement of Science

Fig. 36: © 1982 Nancy Burson, Richard Carling, and David Kramlich

Fig. 37: © 1988 Nancy Burson, courtesy Jayne Baum gallery

SELECTED BIBLIOGRAPHY

RELEVANT ESSAYS AND ARTICLES BY THE AUTHOR

- "Among Banana Trees and Butterflies" (introducing the work of Donna Ferrato), *Fotografia*, Autumn 1986.
- "Beirut: The Photographers' Story," Camera Arts, January 1983.
- "A Day in the Lie of America" (exhibition review), *Village Voice*, December 23, 1986.
- "The Frailty of the Frame" (a conversation with Susan Meiselas), *Aperture* 108, Fall 1987.
- "Fred Ritchin and the State of Photojournalism," interview by Marilyn Stern, *Photo District News*, December 1985.
- "The Future of Photojournalism," *Aperture* 100. Fall 1985.
- "Going to Argentina," Center Quarterly, Winter 1990.

- "Life's Lingering Shadow," Aperture 108, Fall 1987.
- "The Photography of Conflict," *Aperture* 97, Winter 1984.
- "Photography's New Bag of Tricks," *The New York Times Magazine*, November 4, 1984.
- "Photojournalism From Another Land," San Francisco Camerawork Quarterly, Summer 1984.
- "Photojournalism in the Age of Computers," in *The Critical Image*, Carol Squiers, ed. (Seattle: Bay Press, 1990).
- "Photojournalism Since Vietnam," Contact Press Images special ten-year anniversary issue. 1986.
- "Rethinking 'Concerned Photography,' "Center Quarterly, Spring 1987.
- "What is Magnum?" in *In Our Time: The World As Seen by Magnum Photographers* (New York: W. W. Norton, 1989).

ABC-TV news, 23 Adams, Eddie, 140 Advertisement, pictures as environment for, 42 Advertisers, importance of, 46 Advertising photography, influence of, 46 Alborta, Freddy, frontispiece Amateurs, technology and, 69 Another Way of Telling, 121 Approaches, new, 121 Archival photos, transformation of, 138 Archives on video disk, image, 68 Armbrust, Roger, 23 Art director, power of, 69; photography, photojournalism and, 120, 122; photography, synthetic nature of, 5 Artificial intelligence possibility, 140 Associated Press, 20 Audience, fear of, 54 Axelrad, Stephen, 140 Baker, Henry, 25 Bayard, Hippolyte, manipulation and, 13

Baker, Henry, 25
Bayard, Hippolyte, manipulation and Beirut, 122
Bentkowski, Tom, 23
Berger, John, 121
"The Big Lie," 6
Blank, Ben, 23
Book, first published photographic, 1
Bove, V. Michael, 70, 71
Brain images, computer, 131, 133
Brand, Stewart, 74, 128
Brandt, Robert F., 20
Buell, Hall, 20
Burnett, David, 106
Burson, Nancy, 137, 138

Capa, Robert, 34, 72, 87, 88, 98 Spanish Civil War and, 32

Carling, Richard, 137 Cartier-Bresson, Henri, 103, 112, 139 "decisive moment" and, 17 Cartoon characters, human characters and. Cartwright, Guenther, 14, 16 Camera electronic still video, 54, 66; implications of still video, 4; MIT Media Lab "range", 69, 70-71; robot video, 67 Censorship, use of, 1, 38 Characters, creating humanoid, 76 Cinematic fantasy, photography as, 46 Classical photojournalism, 116 Cloning. See Reverse Cropping. Colorization, 21 Compositing, computer, 10, 11, 12 Composition of separate photographs, 9, 10 Computer -based communications systems, 130; compositing, 10, 11, 12; in film industry, 136; generated imaging, mechanism of, 72; graphic capabilities of, 27; NASA use of, 14; photographer's use of, 125; photography effects of, 4; retouching capabilities of, 4; searches of photo libraries, 68; simulation of images, 72; speed of editing action, 13 Computer Pictures, 23 Context of photography, 2 Contextualizing, trend to, 140 Control by photographer, 125 Constructing photographs, 84 Cooke, Janet, Pulitzer Prize and, 88 Cosmetic editing, 26 Cost of technology, 116 Criminal face, identifying, 82–83, 84–85 Cropping, reverse, 20, 79 Cruise, Tom, 8, 9, 10, 11 Culture

photography in context of, 100; and photog-

raphy, link between, 99; in the USA, photog-

Empire State Building, editing, 29, 30

raphy as expression of, 104, 106-107 nipulation. Eppridge, Bill, 55–62 Cyborg, creation of, 76, 77 **Ethics** Daily Me, The, 129 of manipulation, in journalism, 4, 20 Exotic photography, reinventing, 44 Data, digitizing, 13-14, 137 Day in the Life of America, A, 7, 19, 103 Faked photography, 65 Deception, potential for, 142 "Falling Soldier," 87-88, 98 Decision-making power, changes in, 68, 69 Family of Man, 104 "Decisive moment" Fantasy, photography as cinematic, 46 materials and, 103; meaning changes of, 17, Feingold, Deborah, 18 139 Fiction Democracy, photography and, 142, 144 documentary, photographs as, 81, 84, 124 Depardon, Raymond, 120, 121, 124 Film Depth industry, computers in, 136; photojournal of field, manipulation of, 2, 69, 70, 71; Digital and, 120 First Casualty, The, 87, 88 form, photographs in, 13-14; images, permanence of, 67; representation of phenomena, Fitzpatrick, Bill, 16 Format control of photographs, 44 136, 137 Disinformation, potential for, 74 Formula photography, 38, 39, 40, 41 Fractals, 136 Distortion, photographic, 87 France, photography approach in, 104, 105, Documentary 106-107, 108 fiction, 124; photographers as witnesses, 38 Gahan, Gordon W., 15 Dog photo essay, 87, 89-97 Garrett, Wilbur E., 17 Dozo, 76, 77 Gilka, Robert E., 17 Drapkin, Arnold, 22 Drugs, Life photo essay on, 48, 49-53, 54, 55-Genre, differentiating by, 81 Geo magazine, 89-97 62 Georges Pompidou Center, 43 Georgopoulos, Dr., Apostolos, 131, 133 Editorial Gorgoni, Gianfranco, 28 modification, instances of, 17; photography, Government, photographers as opponents of, 31; photography, pre-existing image use in, 48; trend, current, 46 38 Graphic(s) **Editing** action, speed of computer, 13; effect on readcomputer and, 27; paint box art, 24, 25 ers of, 22; photographic, 13 Graves, Ralph, 118 Griffiths, Philip Jones, 118, 119, 120 Editor(s) Guevara, Che, frontispiece as photographers, 67; and photographers, relationship of, 111; power on photography, 69, Halberstam, David, 118 Hicks, Wilson, 33, 34, 44 Eiffel Tower, editing, 29, 30 Hoffman, Dustin, 8, 9, 10, 11, 12 Electronic image, problems of, 4, 5; journalism, poten-How Goes the Press, 43 Haya, Maria Eugenia. See Marucha. tial of, 145; journals, 125, 128; retouching, Human perception of, 63; still video camera, 64, 65, and cartoon characters, 76; simulation, 75; 66 simulation in movies, 76, 77; simulation in Electronic Workshop, 64 stills, 78, 79 El Salvador: Work of Thirty Photographers, 33, Humanoid characters, creating, 76 Emphasis in photography, repetitive, 33, 38, 40, Hyper-medium, potential for, 139

Hyper-photography, 132 media interaction with, 139

Enhancement, concept of, 14, 16. See also Ma

Movies, human simulation in, 76, 77

Murray, William, 74

Image(s) Libération, 121, 128 archives on video disks, 68; computer Libraries, computer searches of photo, 68 brain, 131, 133; computer simulation of, 72; Life magazine, 24, 25, 33, 34, 44–45, 47, 49, exploratory, 33; still-video impermanence 50, 51, 66, 82, 84, 85, 87, 88, 105, 107, 108, of, 65; manipulation, 4, 13, 68; permanence 117, 118; avoidance of realities, 45; motto of digital, 67; problems of electronic, 4, 5; of, 31; photo essay on drugs, 48, 49-53, 54, 55-62; policy of, 23; success of, 32; in still photographs from television, 67; use of pre-existing in editorial photographs, 48; World War II, 38 and words, combining, 126. See also Photo-Light Years: Three Decades Photographing graphs. Among the Stars, 12 Image Bank, The, 68 Literature, photojournalism and, 120 Imagery Lonidier, Fred, 121 creating, 72; fear of visceral, 49, 50, 51; Lucasfilm, 78, 79 interpretation of, 44 Luce, Henry, 31 Imaging, mechanism of computer-generated, Magazine(s) Information, photography as source of, business problems of picture, 42; failure of 144 mass, 42; trend away from reality, 48 Intelligence, artificial, 140 Mandelbrot, Benoit, 136 Interactive media, 129 "Manifesto in Defense of Personalized Pho-International Center of Photography, 116 tography," 112 Interpretation, photographic, 13, 44, 82, 83 Manipulation Invisible, photographing the, 131 ethics of, 4; image, 68; nonphotographer. 88, as old practice, 63; widespread use of, Iran, photo essay on, 114, 115 23. See also Editorial; Enhancement. Johns Hopkins University, 131, 133 Márquez, Gabriel García, 104 Johnson, Don, 17, 18 Marucha, 101, 102 Journal(s), electronic, 125 Mass magazines, failure of, 42 problems of 128 Massachusetts Institute of Technology. Journalism See MIT. need for truth in, 88; pack, 38; potential of Materials and photography, link between, 101, electronic, 145; problems in, 14. See also Photojournalism. Mathematics, simulation by, 80. See also Journalist, photographers as, 121 Computer. Max Headroom, 74 Kennedy, Sen. Edward, photographs of, 85, Media 86, 87 hyper-photograph interaction with, 139; for Kennedy, Thomas, 22 photojournalists, 116 Kirkland, Douglas, 10, 11, 12, 47 Media Lab, the. See MIT. Klein, William, 112 Media Lab, The, 74, 128 Kleiser, Jeff, 76, 77 Meiselas, Susan, 39, 116 Knightley, Phillip, 87 Meyer, Pedro, 99 MIT Media Lab, 69, 70, 129 Kramlich, David, 137 Modification, instances of editorial, 13, 17 Language of photography, 1 See also Manipulation. Lanting, Frans, 19 Moholy-Nagy, Laszlo, 145 Laser scanner, use of, 70 Mohr, Jean, 121 Lasseter, John, 75, 76 Moment, sense of, 103, 104 Last Starfighter, The, 74 Monroe Doctrine, Theme and Variations, Latin American The. 126 attitude to photography, 103; photography "Most Amazing War Picture Ever Taken, as cultural expression, 100, 102, photogra-The," 32

phy, materials of, 101

Le Monde, 121, 124

Museum of Modern Art, 38, 104 Myrmidon Project, The, 74

NASA, computer use by, 14 National Geographic, editing by, 14, 15, 16,

National Press Photographers Association, 64 Nature, Photography and, 1

Negatives, still-video system lack of, 64

Negroponte, Nicholas, 129

New Journalism, The, 120, 122

New photojournalism, 122

New York City skyline photograph, 27, 28,

29, 30

New York Daily News, 6

New York Times, The, 129, 131

policy of, 21

New York Times Magazine, The, 30, 104, 106, 114, 115

Newsday, 20, 21

Newsweek, 8, 9, 10, 38, 40, 118

editing by, 26; retouching policy of, 9

Nonfiction photographs, 81, 84

Notes, 124

Olshwanger, Ron, 21 One Hundred Years of Solitude, 104 Ostby, Ellen, 75

Pack journalism, 38

Paint Box electronic retouching system, 23

Parada, Esther, 126

Paris Match, 105, 107, 112

Pencil of Nature, The, 1

People, simulating, 74. See also Human.

Peress, Gilles, 114, 115

Personality, and photography, 112

Perspective, manipulating, 69 70, 71. See also Depth.

Photo essay

disappearance of, 48

on drugs in Life, 49-53, 55-62; dog, 89-97;

on Iran 114, 115

Photo libraries, computer searches of, 68

Photograph(s)

as basic fact, 9; categorizing, 81; as cinematic fantasy, 46, 47; composition of separate, 9, 10, 11; constructing, 84; in digital form, 14; ephemeral nature of, 2; faked, 65; format control of, 44; journalistic. See Photojournalism; manipulation of, 3, 4; manufacturing, 46; new approaches of, 118; phasing out still, 67; publication control of,

44; reading, 48, 81; reinventing the exotic, 44; responsibility for content of, 110; safeguarding truth in, 81; staging, 44; from television images, still, 67; and words, linking, 105, 109. See also Image.

Photographer(s)

changing role of, 113; compromising the, 110; computer use by, 125; control by, 125; editors as, 67; and editors, relationship between, 111; as government adversaries, 38; as journalists, 122, 123, 124; trusting the, 110; viewpoint of, 111; as witness, 38, 114. See also Photojournalist.

Photographic

distortion, 87; editing, 13; preservation, 67; syntax, 90; synthesis, 64; truth, challenges to, 5. See also Photograph; Photographer; Photography.

Photography

changes in, 3, 68; as communication, 100; computer effect on, 4; context of, 2; and culture, link between, 99, 100, 102; editorial, 31; editors, power of, 111; as expression of American culture, 104, 106; as fabricated medium, 6; formula, 38; importance of advertising, 46; as information source, 144; language of, 1; Latin American attitude to, 103; nature and, 1; omnipresence of, 1; personalized, 112; popular authority of, 7; potential of, 109; repetitive emphasis in, 39, 40, 41; as truth, 1; "universal language" of, 104; vocabulary of, 2. See also Photograph; Photographer; Photographic.

"Photography's New Bag of Tricks," 30 Photojournalism

art photography and, 120, 122, 123; classical, 116; evolution of, 31; film and, 120; formula, 40, 41; literature and, 120, 122; manipulation of, 5; misuse of, 7; new, 122; principles of, 144; subsuming, 31; technology and, 4. See also Journalism; Photojournalist; Publication.

Photojournalist(s)

media for, 116; role of, 110; technology and, 64. See also Photojournalism.

Physical reality, limitations of, 2

Picture(s)

as advertisement, environment for, 42; essay, disappearance of, 48; magazines, business problems of, 42. See also Photograph.

Picture Post, 34

Pixar, cover, 74, 75

of photographs, changes, 69; photography, 1

Powers That Be, The, 118 Scitex America Corporation, 29 Preconceptions, photographs and, 142 Scitex equipment, 20, 22 Pre-existing images, use in editorial photogra-Scitex Response System, 27 phy of, 48 Sekula, Allan, 121 Preservation, photographic, 67 "Self Search," 140 Processes, new, 4 "Self Portrait as a Drowned Man," 13 Prop creation by computer imaging, 74 Serious subjects, treatment of, 54 Proximity, use of, 72 Sieff, Jeanloup, 112 Publication(s) Simulation(s) control of photography by, 44; corporate detecting, 63; human, 75; of images, comcontrol of, 42; role of specialty, 42 puter, 72; of people, 74; sense in, 63; techniques, 26. See also Editing; Manipulation. Ouinceañera, 102 SmarTV, 129 Smith, Alvy Ray, 74, 76, 78 Rain Man, 9, 144 Smith, W. Eugene, 45 Range camera, 69, 70 Space, alteration of, 17 "Rangepic," 70 Spanish Civil War, coverage of, 32 Reader(s) "Spanish Village," photo essay, 45 electronic journals and, 125; objections Specialty publications, role of, 42 to editing of, 22 Speed, still video cameras and, 64 Reading photographs, 48 Staging photographs, 44 Realism Star Trek. 74 bases for, 33; depiction of, 1 Statue of Liberty, "moving" location of, 27 Reality Still(s) downplaying of, 44; judging, 3; of life, human simulation in, 78, 79; photographs, avoidance of, 45; limitations of physical, 2; phasing out, 67; photographs from televimagazine trend away from, 48 sion images, 67; video camera, electronic, Reenactments, simulated, 26 64, 66; video camera, implications of, 4; Reeves, William, 75 video, impermanence of, 4 Relationship Stookey, Paul, 42, 129 depiction of, 8; with photograph, changes Strode, William, 89-97 Subjects, treatment of serious, 54 Rephotographing, retroactive, 17 Syntax, photographic, 90-91 Retouching Synthesis, photographic, 64 computer capabilities of, 4; perception of Szarkowski, John, 38 electronic, 63; selective, 20. See also Editing; Manipulation. Talbot, William Henry Fox, 1 Retroactive rephotographed, 17 Technological innovations, advances in, 64 Reverse cropping, 20, 79 Technology Riboud, Marc, 112 cost of, 116; flexibility of, 113; image ma-Richards, Blair, 16 nipulation by, 4; implications of, 20; photo-Ristelhueber, Sophie, 120, 122, 123 journalist education in, 64; potential, 139 Ritchin, Fred, image by, 29 Television, still photographs from, 67 Robot video cameras, 67 "This is War!" 32, 34 Rolling Stone, editorial modification by, 17, Thought process, depicting, 131, 133 18 Time, 22, 33, 40, 41, 43 Time allocation, 17 St. Louis Post Dispatch, 21 Time-Life Books, 83 Savage Pit, The, 89-97 Tin Toy, 75, 76 Scanner, use of laser, 70. See also Computer. Transformation of archival photographs, 138 Scarborough, Chuck, 74 Truth Science, 133 challenges of photographic, 5; distortions, 12; Science 84, fake picture, 78, 79

Under Fire, 88
United States of America culture, photography as expression of, 104, 106
"Universal language," of photography, 104

"Vision of Iran, A," 114, 115 Video

camera electronic still, 64, 66; camera implications of still, 4; camera, robot, 67; disks, image archives on, 68

Videotape, interactive, 129

Vietnam

dead photo, 117, 118; photo viewpoints of, 42; War, coverage of, 38

Vietnam, 118, 119

Viewing, changes, in, 4, 5

Viewpoints, limiting, 67

Villet, Grey, 49-53

Violence

context of, 33; depiction of, 33, 36;

overexposure to, 33

Virgili, G., 107

Visceral imagery, fear of, 49

Visible and invisible, boundaries between,

131

Visual

fakery, potential for, 74; imagery, digital transformation into, 136, *137* Vocabulary of photography, 2

Vocabulary of photography, 2Vu, 105

War(s)

coverage changes of, 38; Hicks, description of, 34; overexposure to, 33; photo coverage of, 32; visualization, 118

"Warhead I," 137

mandate, 105

Washington Star, 85, 86

Washingtonian, 85, 86

Westmoreland, William, 43

Whelan, Richard, 87, 88

Wileian, Richard, 67, 66

Who Framed Roger Rabbit? 76

Witness, photographer as, 114

Wolczak, Diana, 76, 77

Wolfe, Tom, 120

Words

and images, combining, 126; linking, 105, 109

Words and Pictures, 45

Young Sherlock Holmes, 74

Zimmerman, John, 25